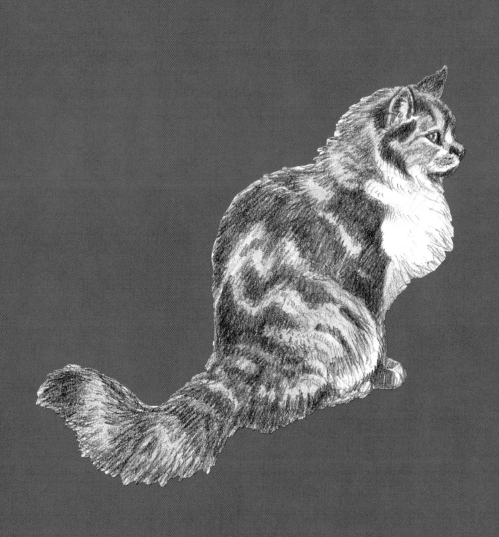

J. C. AMBERLYN

HOW TO DRAW
CATS AND
KITTENS

A Complete Guide for Beginners

MONACELLI STUDIO

Copyright © 2017 J. C. Amberlyn and
THE MONACELLI PRESS

Illustrations copyright © 2017 J. C. Amberlyn

Text copyright © 2017 J. C. Amberlyn

Published in the United States by MONACELLI STUDIO,
an imprint of THE MONACELLI PRESS

Library of Congress Cataloging-in-Publication Data

Names: Amberlyn, J. C., author.

Title: How to draw cats and kittens : a complete guide for beginners / J.C. Amberlyn.

Description: First edition. | New York : Monacelli Studio, 2017.

Identifiers: LCCN 2017018854 | ISBN 9781580935005 (paperback)

Subjects: LCSH: Cats in art. | Kittens in art. | Drawing--Technique. | BISAC:
 ART / Techniques / Drawing. | ART / Subjects & Themes / Plants & Animals.
 | ART / Techniques / Pen & Ink Drawing.

Classification: LCC NC783.8.C36 A43 2017 | DDC 743.6/9752--dc23

LC record available at https://lccn.loc.gov/2017018854

ISBN 978-1-58093-500-5

Printed in Singapore

DESIGN BY JENNIFER K. BEAL DAVIS
COVER DESIGN BY JENNIFER K. BEAL DAVIS
COVER ILLUSTRATIONS BY J. C. AMBERLYN

10 9 8 7 6 5 4 3 2 1

First Edition

MONACELLI STUDIO
THE MONACELLI PRESS
6 West 18th Street
New York, New York 10011

www.monacellipress.com

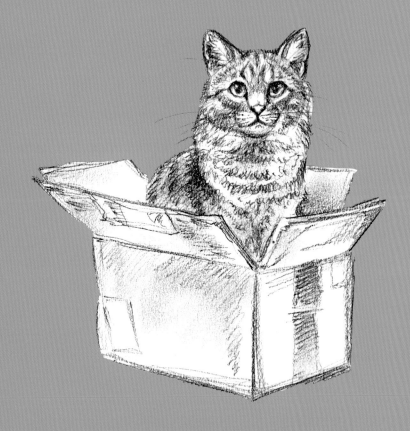

Dedicated to Den. We will meet again on that bright, distant shore.

ACKNOWLEDGMENTS

I'd like to thank Amanda Gonsalves, Ana Gonsalves, Aaron Ricca, Amy Fennell, Amy Pronovost, Anouk Adel, Ashanti Ghania, Ashley Lungwitz, Beth Tereno, Dan Ramos, Dana Johnson, Dani Repp, Gen Whitmore, Hannah Davis, Windy Adams, Joy Kobasko, Megan Giles, Primp My Pet, Roz Gibson, Scott and Rachel Bross, Stephanie Cress, Teri Gray, Warren Adams-Okrassa, and everyone else who helped me while I worked on this book. I've enjoyed getting to see each of your fantastic feline companions. I'm thankful for Sheba, who was the most beautiful cat I ever knew, and my feral cat, Cleo. Thanks to those who help stray cats by making trap, neuter, and release programs possible.

ABOVE: If I fit, I sit.

CONTENTS

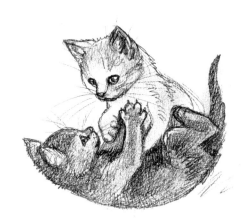

INTRODUCTION

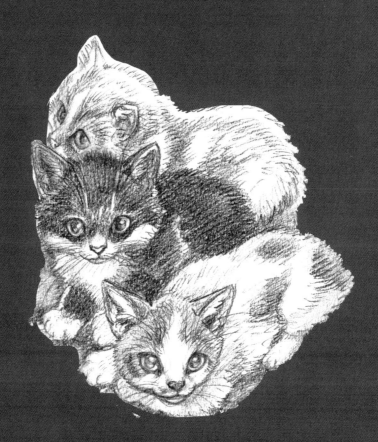

Since ancient times, humans have been fascinated with the cat's unique blend of grace and beauty, superbly adapted purpose, and independent character. Cats have provided us with the valuable service of rodent control, but more than that, they have decided that we are worthy of their companionship. This bond has to be earned, but when it is there the cat is a devoted and loyal friend. As a subject of art, the cat is an exquisite model: flowing, flexible grace balanced with strength and sharp claws concealed inside soft, fuzzy toes. The cat can be a charming cute ball of fur or a mysterious, elegant, even aloof figure. It can be a hissing, pouncing flash of fangs and claws or a soft, seemingly spineless figure reclining lazily in front of a window without a care in the world. With a stunning variety of breeds, colors, and patterns, the cat has caught the artist's eye for centuries. Hopefully this book will help you in your journey to understand both the cat and bringing its likeness to life on page or computer screen. This book will delve into anatomy, which is the foundation for drawing realistic animals, followed by a look at drawing kittens, a look at actions and expression, and a chapter on some of the more notable cat breeds.

ABOUT THIS BOOK

This book is meant to be a guide to understanding cats and both the physical and behavioral aspects that make them uniquely feline. Knowing your subject gives you greater ability to depict it realistically. This book contains information on the cat's anatomy and expressions as well as numerous step-by-step drawing guides throughout. Look through the step-by-step instructional guides and choose one that looks appealing to you. Pick a simple drawing, such as a sitting cat or drawing a head, if you are feeling at all unsure. Don't be afraid to make mistakes; mistakes are how we learn. Mistakes—and the willingness to make them—are the only way to improve your art in the long run.

There are many cat breeds and it was beyond the scope of this book to include all of them. The last chapter contains information on some of the more common and unusual breeds. Continue your own research to look into the various breeds and what makes each unique. I hope this book will help you in your journey as an artist and perhaps offer some insight into the world of the enigmatic cat.

ART MATERIALS

Art can be made with almost anything, but there are some time-tested materials that are good to know about. You can produce art both traditionally (such as drawing with pencil or pen on paper) or digitally (using a computer or graphics tablet). For traditional work, look for acid-free inks and drawing paper that won't yellow and fade with age as much as materials that aren't acid-free might. You can find sketch and drawing pads of various sizes and see which ones you like the most. Larger pads allow you to create bigger drawings but smaller pads can be easier to keep near you at all times, for whenever inspiration strikes. There are different kinds of art paper, from light sketch pages to heavy bristol board that can withstand a lot of erasing. Experiment with pens and pencils. Pencils are softer and more forgiving; pens have impact but mistakes are harder to fix. I like to use brush pens for sweeping, variable lines in larger images and use exact widths (such as 0.2, 0.5, and 1.0 sizes) for tighter, controlled detail work.

Artist pencils come in varying hardness or softness. A 9H is a very hard pencil with a light stroke. A 2H is still on the hard side but isn't quite as hard as the 9H. Midrange pencils are the HB and the 2B, which then rises in number to the 9B pencil, which is extremely soft and dark. Artists may use an H pencil (such as a 2H) to lightly place the figures on the page. They can then go back with a darker, softer pencil in the B range (such as a 2B) to draw the final picture. I used a mechanical pencil (HB or 2B) for many of the drawings in this book, using a very light touch to my pencil strokes as I blocked in the drawing. I then pressed more firmly on the paper as I finished the drawing. If you are using pencils you will probably want an eraser. There are several specialty artists' erasers out there, including the kneaded eraser. The kneaded eraser allows you to shape it so that you can get the most precise erasing possible.

If you are using a computer you will want it fast enough and with enough memory to handle the graphics-heavy programs you'll need. You may also want to consider getting a graphics tablet. This allows a person to draw with a pen on the tablet, which many find easier than trying to draw with a mouse.

Chapter One

CAT ANATOMY

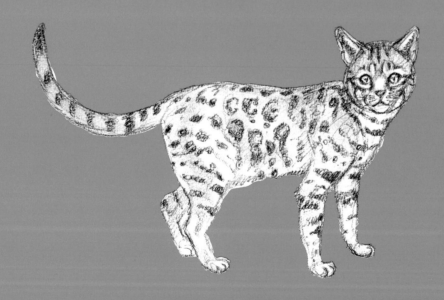

Understanding some of a cat's basic anatomy will help you draw more convincing felines. Bones and muscles create a structure that helps give weight, strength, and balance to the cat's form and to your drawing of it.

THE SKULL AND BASIC HEAD STRUCTURE

The cat has a rounded head with a short muzzle and comparatively large eyes.

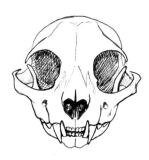

This is a cat skull from the front view. Note how rounded it is and how comparatively big the eye sockets are.

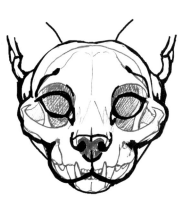

Here's a front view of a cat head with no skin or fur, but showing some of the muscles and sinew that affect its shape. The skull can be seen underneath. The area around the lips and muzzle is very fleshy.

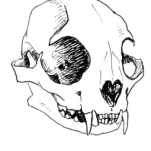

Here's the cat skull in three-quarter view.

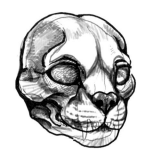

Here are some of the muscles and sinew on a cat's head as seen in a three-quarter view and showing the skull underneath.

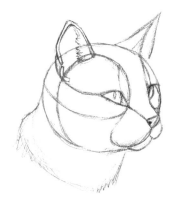

This is the head angled at a three-quarter view and showing some of the basic interconnecting shapes that link the features.

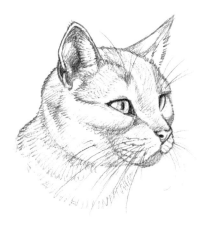

The finished drawing shows how it looks in life.

HOW THE CAT HEAD COMES TOGETHER

These sketches show the structures of a cat's head in a stylized manner to illustrate some ways of visualizing how a cat's head pieces together. Study these and make your own observations as well.

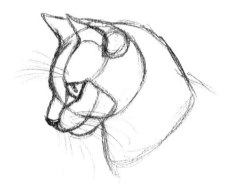

Note how many of the lines and shapes blend into one another, like the way the mouth sweeps up to the cheeks or the outside corner of the eye "points" to the bottom of the ear.

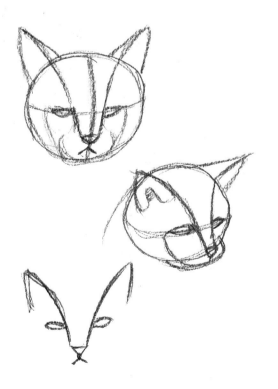

One thing that can be useful to keep in mind is how the line of the nose sweeps up to meet the eye and then can be continued in one's imagination (you wouldn't actually draw this extended line) to hit the inside corner of the ears. This triangular area can help you position the nose, eyes, and ears as you draw a cat's head, especially from the front.

DRAWING A CAT HEAD, FRONT VIEW

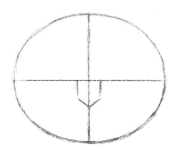

1 First, draw an ellipse that is fairly round but slightly wider than it is tall. Separate it with a horizontal guideline and vertical guideline that form a plus sign in the center. Then add two parallel vertical lines, with a V shape at the bottom, attached to the horizontal guideline in the center of the bottom half of the head, as shown. This badge-shaped area will be the bridge of the nose and the nose pad.

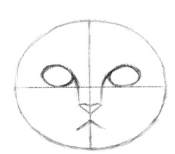

2 Draw the eyes resting on top of the horizontal guideline. Extend the parallel lines of the nose up into the corners of the eyes and continuing into the oval shapes of the eyes. Define the triangular nose pad, and add the mouth.

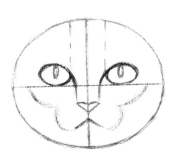

3 Add the pupils to the eyes. Start defining some of the shapes of the face. These are influenced by bone and muscle underneath, as shown with a cat skull. Lightly block in the muzzle around the mouth and the bony ridges of the cheeks under the eyes. Also block in some lines (dotted in this drawing) from the inside corners of the eyes up to the top of the head. This will help you place the inside corners of the ears.

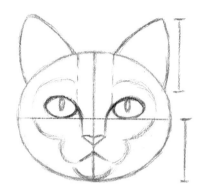

4 Now add the ears. Notice that the height of the ear is about equal to the distance from the bottom of the head to the center line. Draw the cat's chin. Also go ahead and block in the bony ridge above the eyes, continuing the line from the cheeks.

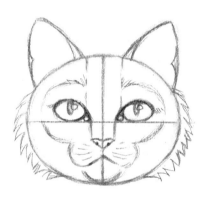

5 Define some of the rims of the ears, especially the inner corners and the ear pockets on the outside edges. Lightly block in the whisker rows and the nostrils. Add some highlights to the eyes and small circles in the corners of the eyes to indicate the tear ducts. Add some suggestion of fur above the eyes and in the ruff along the cheeks.

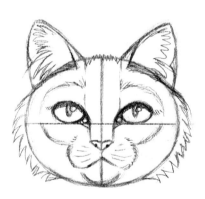

6 Finish blocking in the drawing, adding some definition to the muzzle, the insides of the ears, and the fur along the top of the head. Note that I drew the hair tufts inside the ears slightly overlapping the top of the head. Further define the tear ducts, and add some shadow in the eyes under the eyelids.

7 Draw dots along the whisker rows instead of actual lines, and add the whiskers (you can use a thinner pen or pencil for this if you like). To finish the drawing, I inked in the cat head and erased the pencil lines.

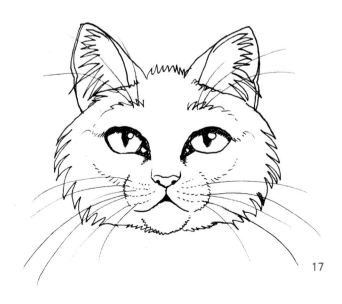

17

DRAWING A CAT HEAD, SIDE VIEW

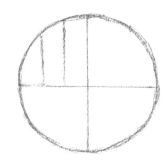

1 Draw a circle, and place horizontal and vertical guidelines that cross in the middle to divide the circle up into four equal parts. Then, divide the top left quarter into three equally wide vertical sections.

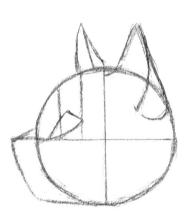

2 Add the muzzle on the left side of the head. Extend a line from the horizontal guideline to place the top tip of the nose, and line the chin up about equally with the bottom of the head circle. Draw the eye in the top left quarter, using the previously drawn vertical divisions as a guide: the area of the tear duct creates a slanting, somewhat triangular shape on the left-most third of that section; the eye itself is in the middle third. Block in the ears as well. Note that the outside corner of the closer ear begins at about the center of the top right section of the head. It extends up and above the head circle and swoops down again to meet the top center of the head. The farther ear begins at about that point and extends up and back down to line up with the outside corner of the eye.

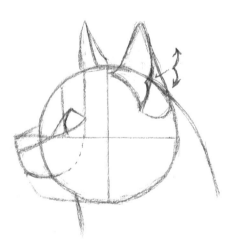

3 Add definition to the eyeball, drawing a curved line to show its round shape as it bulges from the eye socket. Extend the line from the tear duct in a straight but slanted line all the way to the tip of the nose. Draw a slightly curved line under it for the mouth, and note how that line could be continued all the way up (as shown by the dotted line) to meet the outside corner of the eye. Indicate the ear pocket on the outside curve of the near ear with two small arches (as shown by the arrow to the side). Add lines indicating the throat and back of the neck. The neck slopes out from the arch of the back of the head.

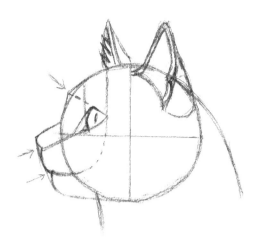

4 Add the pupil to the eye. Draw the rims of the ears, and add the tufts of hair inside the far ear. Draw a slight bump on the forehead to indicate the brow; note how a line extended from the top of the eye basically points to the highest bump on the brow ridge (shown by the dotted lines and arrow). Draw depressions under the nose and at the mouth to give shape to those parts of the cat's facial anatomy (indicated by the two bottom-most arrows at left).

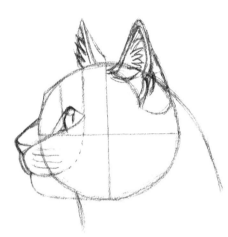

5 Now add the line that extends from the bottom of the nose to the mouth, making sure it is almost on the edge of the profile. The lower jaw protrudes up, creating a subtle upside-down V shape where the lower lip meets the two upper, whisker-lined lips at the mouth. The bottom of the nose creates a triangular shape that points down. Add the top of the nose pad, completing the triangular shape. Block in a highlight for the eye and hair tufts inside the closer ear. Draw an extra fold of skin behind the ones you already drew for the ear pocket, if you like. Block in four whisker rows.

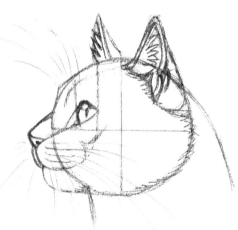

6 At this point, the drawing is almost done but just needs a few refinements. Add the whiskers sprouting from the whisker rows. Shade a little under the top eyelid, darkening the top line of the eye. Add the nostril. Lightly indicate some features in the anatomy, such as the bony ridge under the eye that forms the cheek and the rounded back part of the muzzle. Indicate the slightly bony ridge above the eye that slopes down toward the nose. Suggest fur around the rim of the head and jaw, and along the bottom of the near ear.

7 Finish the drawing. In this case, I inked in the final drawing, and once the ink was dry, I erased the pencil lines.

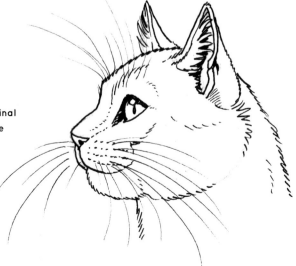

DRAWING A CAT HEAD, THREE-QUARTER VIEW

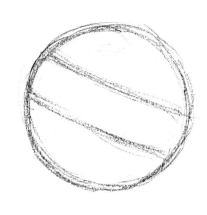

1 Draw a circle with two diagonal parallel lines dividing it into thirds. These dividing lines will help you block in the rest of the cat's head later.

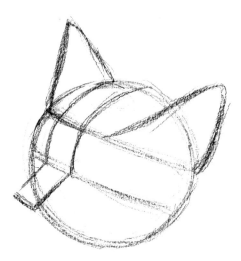

2 Add the top of the nose, using a straight line that runs parallel to the other angled dividing lines and juts out just slightly from the main circle shape. The bottom corner should almost meet the main circle but not quite. Continue two lines up from the nose, straight at first and slightly curved as they travel up around the head. This will help you place the eyes. Add the ears, drawing the inside corners a little bit outside the eye and nose lines you just placed, and continue outward. Note how the outside angle of the closer ear meets the top dividing line you originally drew. The back of the far ear meets one of the eye/nose lines.

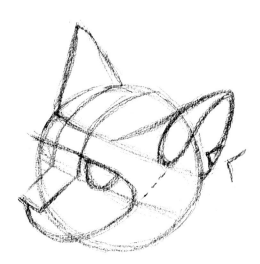

3 From the nose, draw the muzzle, using a curved line that turns back and inward and that points toward the inside tip of the cat's closer ear. Curve it around sharply once you hit the original, bottom dividing line inside the head. This is where the "cheek" would be. Angle it back around, parallel to the original dividing lines to indicate where the top of the eyes will be. Draw this line about half way between the two original dividing lines. Add a wide, almost U shape underneath to indicate the closer eye. Now add details to the closer ear; draw a J shape that forms a teardrop in the front portion of that ear. This is the outside rim (on your left) of the ear and the edge of the hair that adorns the inside of the ear. Then add a sideways V shape; this will be the ear pocket.

4 Now add pupils to the eyes and a line from the top inside corner of the near eye that connects to the line of the top of the nose. Add a small upside-down triangle for the nose, and round off the tip at the very top of the profile. Draw the jaw and a line that connects from the eye/nose line down to the mouth and indicates the curve of the muzzle. Add the farther eye, which looks smaller than the closer eye from this angle. Draw the farther cheek under the distant eye, making it curve in toward the eyeball. Finally, draw a line defining the ruff of fur on the cat's cheek, connecting the inside corner of the closer ear to the jawline. Use some squiggly lines if you wish to indicate furriness.

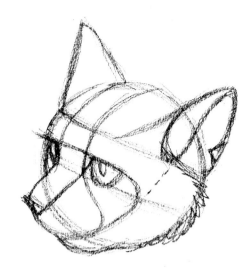

5 Finish blocking in the head. Add highlights in the eyes, more definition to the hair inside the near ear, the nostril, and four lines where the whisker follicles are on the muzzle. Note how the top line of the whisker rows can be drawn to continue and connect with the bottom of the closer eye. Add the back of the neck, drawing a curved line that doesn't quite reach the tip of the closer ear, and then the throat. You can connect them with a lightly suggested ruff of fur at the base.

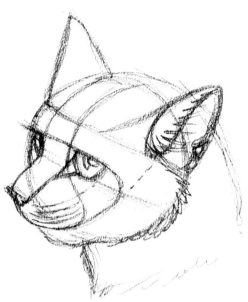

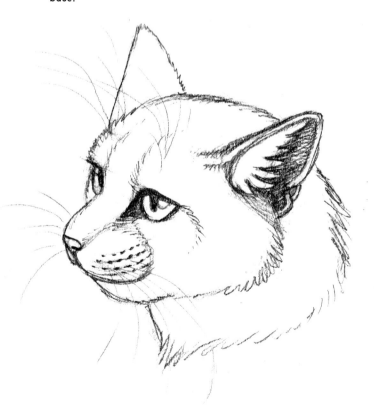

6 Finish the drawing. Partially erase the guidelines, or work over them with a fresh sheet of paper on top, and draw the final lines. Add the whiskers and line scribbles that indicate fur, such as in the corners of the eyes. Also shade in the tear duct of the closer eye. Add a little dividing line going down from the tip of the nose to the top lip.

EYES

Cats have large, striking eyes that come in many different colors, from blue to yellow to brown or green. The color is usually solid; however, in some cases cats may have different-colored rings around their pupils, different-colored patches in their eyes, or one eye of one color and the other a different hue. An albino cat will have pink eyes. Kittens are born with blue eyes. These may change color; a young cat should have its adult eye color by about three months of age.

The cat eye is a highly specialized tool. Cats can see much better in the dark than humans. Their pupils are part of the reason. A cat's pupil is shaped like a vertical slit in the eyeball. It can expand or contract as needed. When expanded, it appears almost round, like a human pupil, which helps it gather as much light as possible so that it can see in dim lighting (right, top). When in bright sunlight, the cat's pupil contracts to a slit, protecting it from too much light (right, bottom).

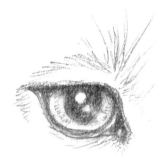

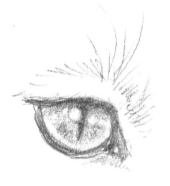

DRAWING A CAT EYE, FRONT VIEW

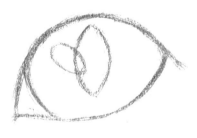

1 Draw the outline of the eye, which is a somewhat slanted oval, and add a triangular shape in the inner corner of the eye where the tear duct will be. Draw a crease on the opposite side on the outer corner. Add the pupil and a small, overlapping oval for the highlight.

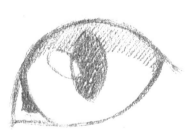

2 Begin shading in the pupil and the shadow of the upper eyelid, adding a small shaded area below the top of the eye. Keep the eye highlight blank. Shade a smaller triangular shape inside the tear duct to indicate the actual duct itself and the crease in the inner corner of the eye.

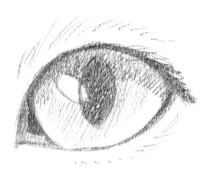

3 Continue lightly shading most of the eyeball, leaving the bottom rim blank for now. Add some tone to the rest of the tear duct, and begin adding suggestions of the fur around the cat's eye.

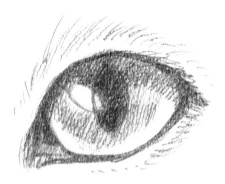

4 Add some longer strokes around the eye, suggesting more of the fur. Shade in more of the dark fur around the tear duct, softening the effect. Go back over the eye to darken the shadow of the upper eyelid and the pupil. Shade more of the eyeball itself, keeping a lighter horizontal streak in the middle along where the highlight is. This suggests light reflections playing on the eyeball's surface. Add some thickness to the lower eyelid if needed.

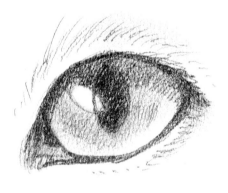

5 Smudge the eyeball to soften it. Also smudge some of the fur above the eye, the outside corner, and anywhere else you think it needs to be softened some.

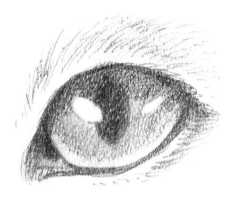

6 Finish the drawing by erasing the lines inside the highlight. Go back and add pencil lines where needed over the blended, soft areas to define them again. I added a smaller, softer highlight on the other side of the pupil. I also used light shading to make areas in the eyeball blend together better.

DRAWING A CAT EYE, SIDE VIEW

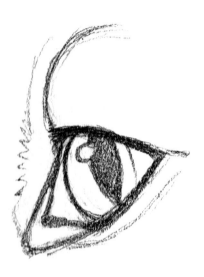

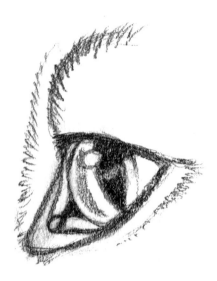

1 Draw the basic outlines of the eye, the tear duct and the groove from the tear duct toward the nose, and the brow line over the eye. Include the pupil and a highlight. Keep in mind that the eyeball is rounded, and the front of the lens of the eye has some slight transparency from this side angle.

2 Darken the pupil, leaving a lighter shading along the middle where light streams in. Darken just behind the pupil as well, where the iris is, showing some of the shadow falling from the top of the cat's eyelid. Define the tear duct, leaving a lighter oval spot on the tip where slight moisture catches light. Begin shading a light tone in the front of the eye, following the curve of the eye. This is where darker shades from the other side of the eyeball can be seen. Begin drawing in a little of the fur surrounding the eye.

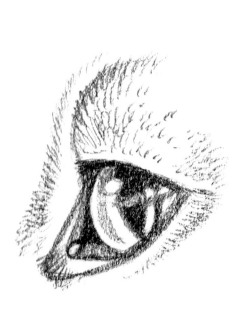

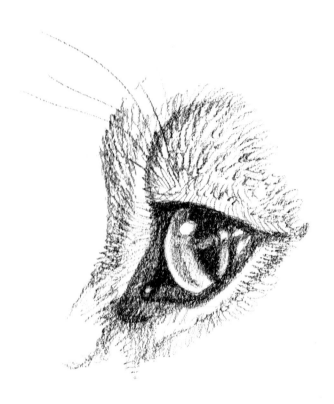

3 Add more indications of a soft highlight cutting across the pupil and back toward the corner of the eye, using light shading underneath to define it. Shade the portion of the eye under the top eyelid just above and in front of the big highlight, and continue shading down into the tear duct. Be sure to leave the moist tip light. Begin shading the groove heading from the eye to the nose, and start adding hairs around the eye.

4 Finish the drawing, lightly shading in the iris around the pupil. I left the very bottom unshaded to indicate sunlight streaming into the eyeball and to give contrast to the darker areas. Fully shade in the tear duct, leaving a small area unshaded to indicate light reflecting on moisture. Fill in the fur details, using longer strokes when needed, and draw the whiskers above the eyes.

NOSE AND WHISKERS

A cat's nose consists of a triangular, hairless nose pad that in a healthy cat is slightly moist. The top of the nose has short hair. There is a vertical split down the center of the nose that creates a distinctive line leading down to the mouth. On either side of that crease are horizontally placed whisker follicle rows. Generally, there are four noticeable rows on each side of the muzzle. Note that the top two rows are a little bit shorter, while the bottom two extend closer to the nose itself.

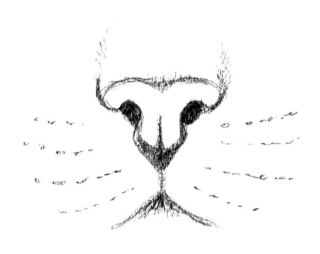

This front view of a cat's nose shows the whisker rows as well.

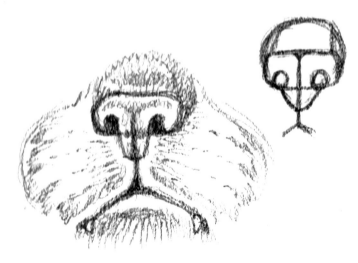

Here is a view of the nose as the cat looks upward.

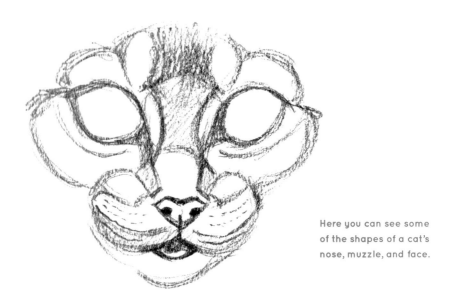

Here you can see some of the shapes of a cat's nose, muzzle, and face.

DRAWING A CAT NOSE

Begin with a jelly-bean shape. Add candy cane–like shapes to indicate the nostrils and lower part of the nose pad. Draw a V shape at the bottom to finish the nose pad shape, and draw the vertical crease that extends from the mouth up to the nose pad. It goes up about halfway.

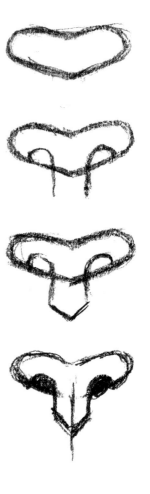

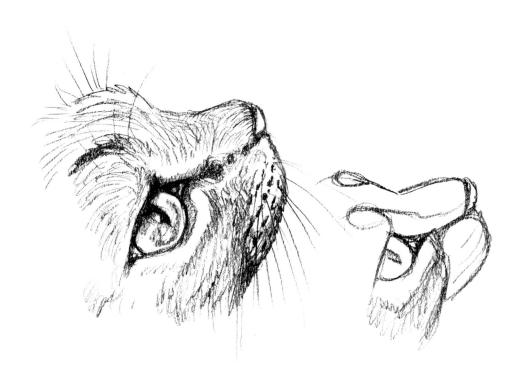

In this view of a cat from slightly above as it looks up, notice how the nose slopes down and the nose pad is visible only at the very tip.

In the three-quarter view, note the almost heart shape of the nose pad. Also note how the main component of the nostril is a darkened circle, with a flap of skin above it that sweeps back from there, creating a crease behind it (indicated by the arrow).

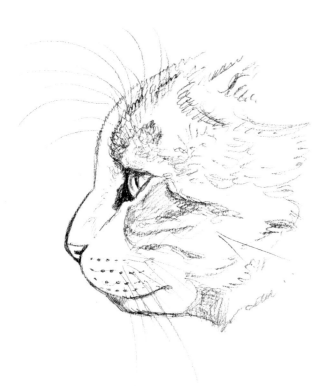

View of the cat's nose from the side.

When drawing the nose from the side, draw one bump for the nose and another for the upper muzzle below it; then add the nose pad. Finish by drawing the nostril.

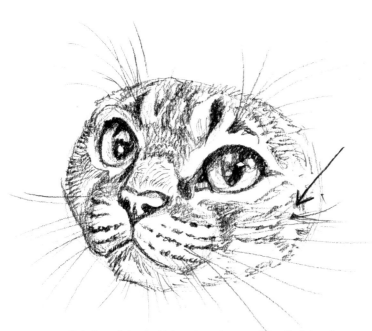

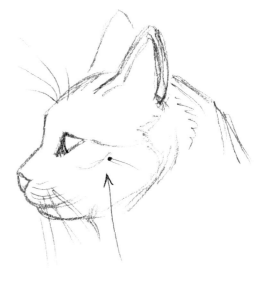

Cats have lots of whiskers in various spots on their heads. One of those places is on the muzzle, as explained earlier. There are also bunches of whiskers above the eyes, set just a little wider than the inner corners of the eyes. They are where the "brows" of the cat would be. Sometimes, cats have stripes or other markings right where these whiskers occur. Additionally, they may have a whisker or two visible on their cheeks, a little below and behind their eyes (indicated by the arrows). There may be a few whiskers visible on the chin as well. Whiskers usually appear a little bit haphazard. They don't occur with perfect spacing on every surface. Some appear a little thicker than others, too. Something else to note is that when a cat yawns, its whiskers may stretch out in front of its face (see page 30, bottom right).

29

MOUTH

Cats have a short muzzle and sharp teeth. The most prominent of these are the canine teeth, or fangs, in the front: two on the top and two on the bottom jaw. Cats also have smaller teeth between the two fangs called incisor teeth. The tongue of a cat is a specialized tool. Rough and sandpapery, it helps the cat remove meat from bones and groom itself. It is rough because it is covered in small, hook-shaped bumps called papillae that point back toward the throat. This efficiency has a downside, as excess hair the cat scrapes off in grooming can get trapped and swallowed. This is why cats sometimes spit up hair balls.

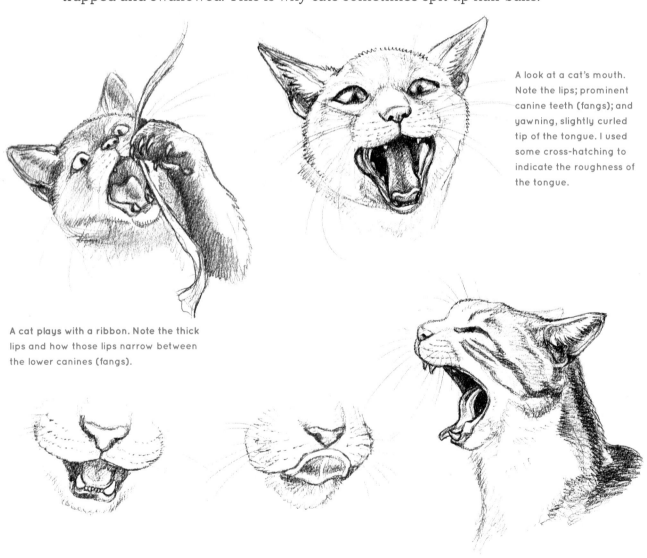

A look at a cat's mouth. Note the lips; prominent canine teeth (fangs); and yawning, slightly curled tip of the tongue. I used some cross-hatching to indicate the roughness of the tongue.

A cat plays with a ribbon. Note the thick lips and how those lips narrow between the lower canines (fangs).

This view of the open cat mouth shows some of the lower teeth.

When a cat licks its nose, note the ridges in the middle and on the rim of the underside of the tongue.

When a cat yawns, note the smooth stretching skin of the lips visible in the corner of the mouth.

EARS

Cats have triangular ears, which aid their excellent hearing. They can prick forward or swivel around to flatten behind them (see opposite, bottom right). Some cats have small tufts of hair on their ears, though not with the length of some wild cat species.

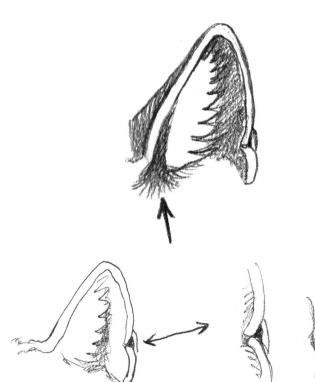

Here is a simplified shape of an ear from a front view. Note the swath of hair sweeping down the inner ear, dividing it in half. The rest of the ear has some hair, too, but the inner swath is often the most pronounced. Also note the short swath of hair between the inner rim of the ear and inner swath of ear hair (indicated by the arrow); it's good to be aware of this feature, especially when doing detailed drawings of fur on the cat's head.

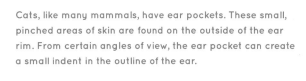

Cats, like many mammals, have ear pockets. These small, pinched areas of skin are found on the outside of the ear rim. From certain angles of view, the ear pocket can create a small indent in the outline of the ear.

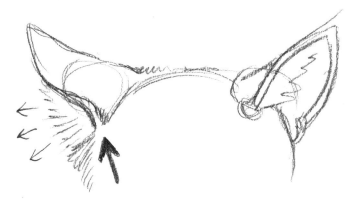

The ears here are pointed in different directions, one forward and the other back. Also good to note here is that the cat's ears are closest to each other at the inside corners. The rim of the ear along this area extends just a little bit forward, where it attaches to the head. This creates a short rim of fur that is sometimes quite evident as you draw the ears (the large arrow points to an example of this). The rim curves toward the face, and the inner swath of ear hair poofs out from there toward the side (as the smaller arrows indicate).

BODY

The cat body is graceful and built for quick action. Unlike the dog body, it doesn't have the deep chest of a long-distance runner. What it does have is a very limber spine that makes the cat good at crouching, creeping, and dashing for periods of fast action as it pounces on prey or uses its agility to escape predators.

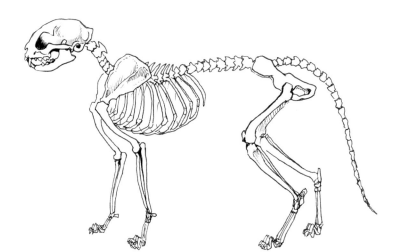

This is the basic cat skeleton. It has a long, flexible spine and a long tail. However, some kinds of cats do not have tails beyond a small stump.

Shown here are the muscles of a cat. The hindquarters are well developed, ready to crouch and then leap forward to spring on prey.

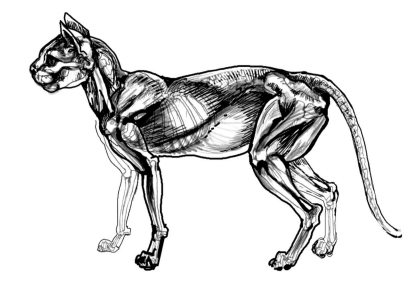

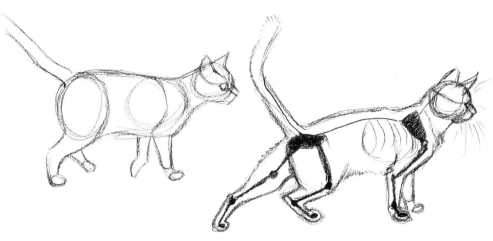

These two simplified drawings break down the cat body into basic structures and shapes.

In these stylized drawings, note how one shoulder of the bottom cat sticks up while the other shoulder sags down as the cat walks. The weight-bearing leg sometimes has a visibly higher shoulder than the non-weight-bearing opposite limb (see arrow).

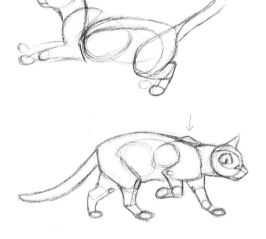

SITTING

The fur obscures some of the cat's anatomy here, giving the hind leg a rounded shape without much definition. The way the fur overlaps and compresses in spots where the muscles curve away from the viewer's eye can still be seen as the cat sits.

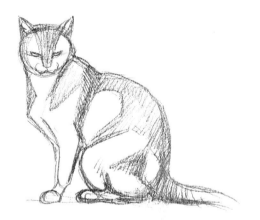

FRONT LEGS

Cats have lean but muscular front legs ready to pounce, stretch, or grasp objects or enemies with their claws.

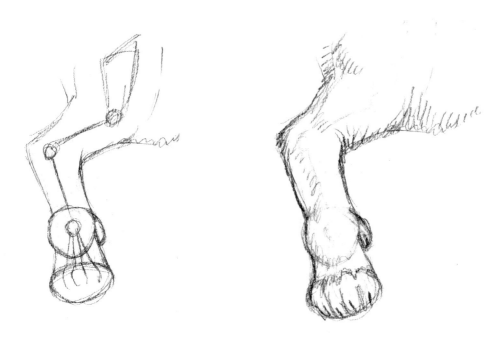

Here is a shoulder blade (top), elbow, wrist (the circle shape), and foot. Note the underlying structure of the toes and claws under the rounded, soft appearance of the front foot.

This more finished drawing shows how the front leg looks to the human eye. Note the toes still appear soft and rounded, but slits can be seen in the front where the claws come out. (They are retracted here, however.)

This cat has folded its front legs and tucked them into its chest. The closer front paw can't be seen, because it is curled under the chest, away from the viewer.

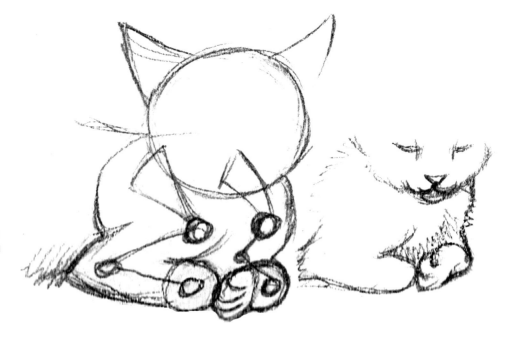

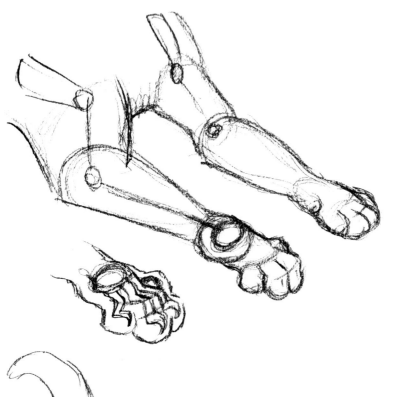

This look at the front legs resting on the ground shows some of the underlying structure. We'll look more at paws on page 38, but note here that the cat is flexing its paws on the ground, stretching its toes, and so there is some tension to them, especially the cat's right front paw (the middle paw in the drawing). The left-most drawing shows a closer look at that paw, and the inner bone and claw structure. Note that the claws are retracted.

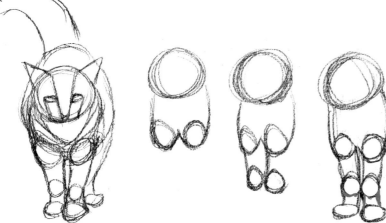

A stylized breakdown of the major components of a cat's front legs from a front view. These are slightly exaggerated to emphasize the leg joints and shoulders.

Another stylized look at the front legs showing the basic leg structure. Arrows highlight the contours of the surface.

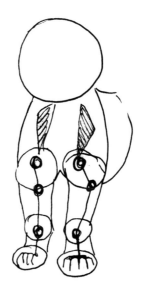
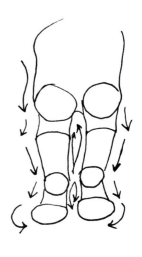

HIND LEGS

The hind legs of a cat tend to be thick and muscular. The haunches may appear quite rounded at certain times, like when the cat sits down and fur obscures more of the detail underneath. If it stretches its legs out, however, the legs show more of the underlying shapes and anatomy and appear a little thinner comparatively.

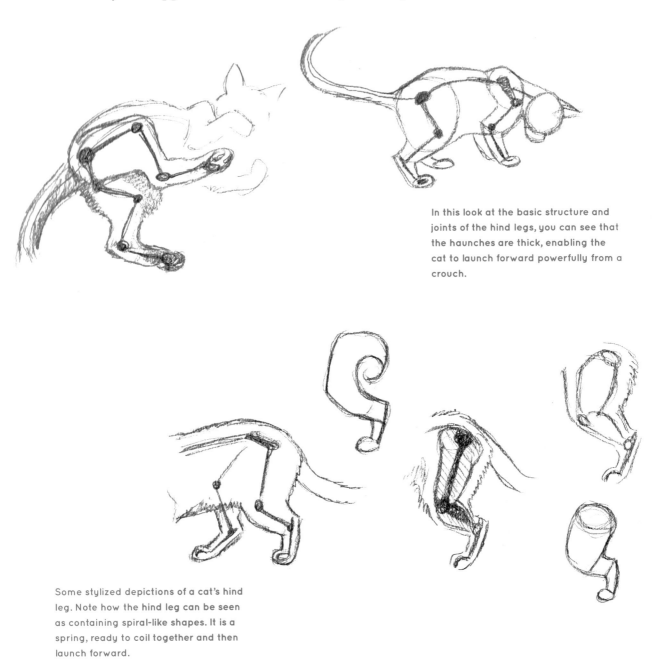

In this look at the basic structure and joints of the hind legs, you can see that the haunches are thick, enabling the cat to launch forward powerfully from a crouch.

Some stylized depictions of a cat's hind leg. Note how the hind leg can be seen as containing spiral-like shapes. It is a spring, ready to coil together and then launch forward.

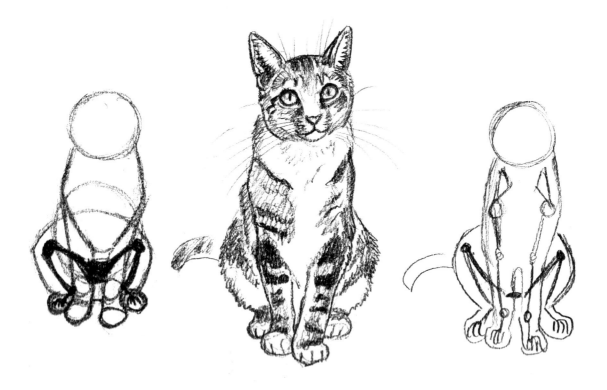

Note the bone structure of the hind legs in a seated position from the front view.

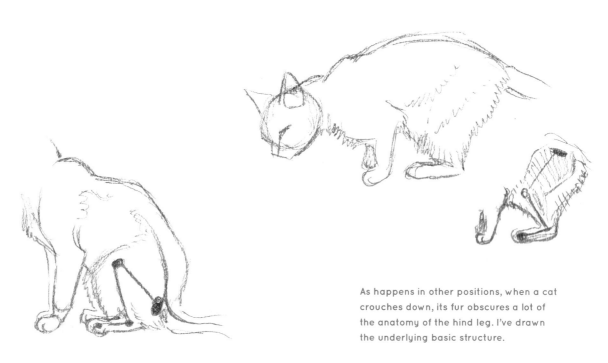

In a seated position, the structure of the hind leg may get a little obscured underneath all the fur, and only really shows through the way the fur overlaps on the flank or hip.

As happens in other positions, when a cat crouches down, its fur obscures a lot of the anatomy of the hind leg. I've drawn the underlying basic structure.

PAWS AND CLAWS

Cats have very soft, rounded paws. They usually have four main toes and a smaller toe—called a dewclaw—placed, much like a thumb, on the inner part of the front paw; however, some cats may have more toes than usual, up to eight toes per foot. These are known as polydactyl cats. One unusual feature found in cats is that they can retract and extend their claws. When the cat's paw is relaxed, the claws remain sheathed inside the skin and fur of the toes. The cat can extend its claws, which remain sharp, since they're not being constantly worn down by wear and tear on the ground like, say, a dog's. These sharp, hooked claws help the cat climb trees or grip prey.

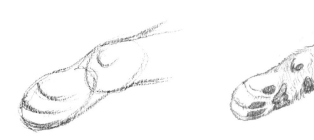

This simplified sketch shows the basic shapes of the front paw at rest and angled with the side up so that the pads are visible.

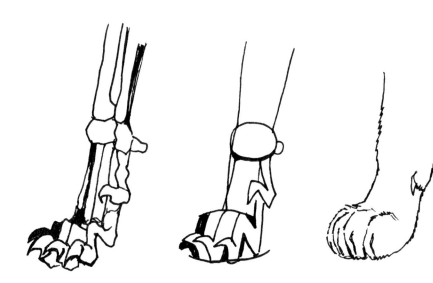

These cat paws are seen from a three-quarter angle. On the left is a look at how the bones would be placed, in the middle is a more stylized look at the bones, and on the right is a view of the paw the way we would see it. Note how the dewclaw can be seen on the inside portion of the leg, and how while the claws aren't visible, the slits in the skin where the claws are sheathed are visible.

Compare the paw with claws retracted (top) to the paw with claws extended (bottom).

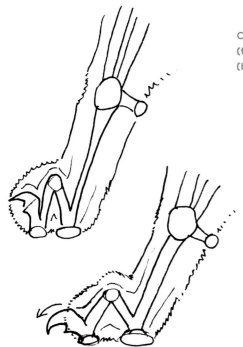

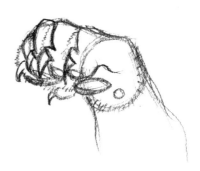

With claws extended, the cat can use its paw to swat at objects and try hooking them with its claws, much the way a human can hook and grab objects with fingers.

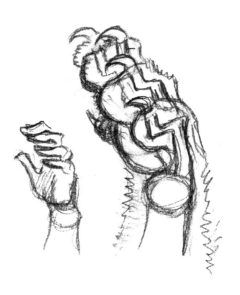

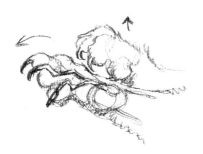 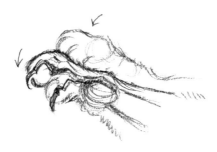

Cats are well known for "kneading" their paws, stretching their toes and then curling them back inward, alternating the motion between the two front paws. They often do this when contented. Claws may be extended or kept retracted. They may also use all four paws when kneading.

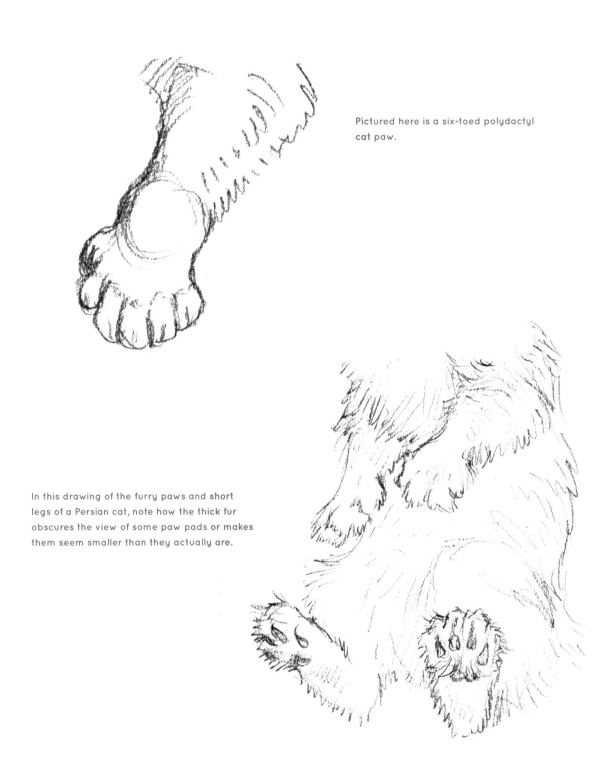

Pictured here is a six-toed polydactyl
cat paw.

In this drawing of the furry paws and short
legs of a Persian cat, note how the thick fur
obscures the view of some paw pads or makes
them seem smaller than they actually are.

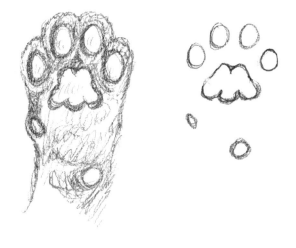

The basic cat paw as seen from underneath provides a good look at the pad placement. There are four toes, with one paw pad each (if the cat has more toes, each toe normally has a paw pad). The cat has a larger pad at the center of its paw, which has two lobes near the toes themselves and three lobes toward the heel. There is a much smaller pad where the dewclaw is and another pad located farther up the leg along the wrist joint.

This raised left front paw shows how soft and round the paw appears, and how the short hair gives a cat's toes a velvety appearance.

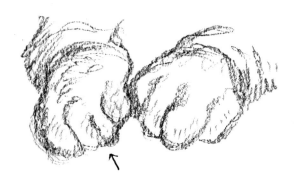

A cat may have relaxed toes, and a rigid structure isn't always immediately apparent on them, especially viewed through all that soft fur. Note how some of the visible lines of this drawing depict the division of one toe from another, but there is also a line that is created not by the division of toes but where the claw sheath is placed on the toe (see arrow).

TAIL AND FUR

Most cats have a long, graceful tail that they can carry high or low, depending on mood. The tail expresses emotion and helps the cat keep its balance. There are a few cats without tails, such as Manx cats. Cats have very soft fur that can range from short to long. They spend a lot of time grooming themselves to keep that fur soft and sleek.

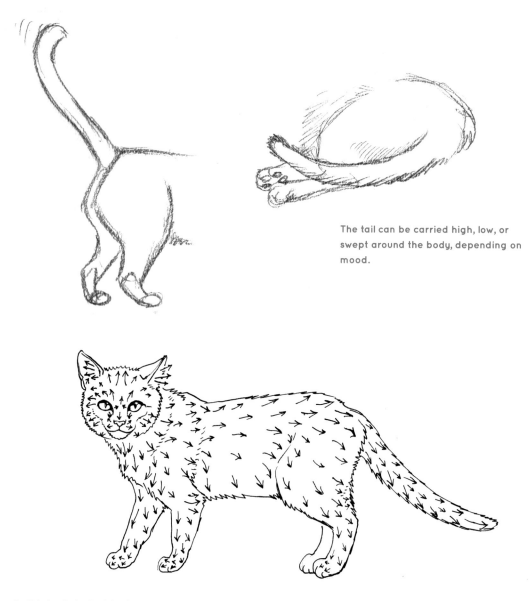

The tail can be carried high, low, or swept around the body, depending on mood.

As this basic look at body hair direction shows, for the most part, cat fur flows out from the face and back on the body.

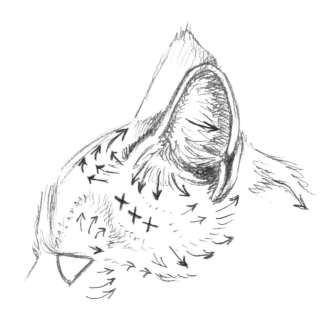

The arrows here depict the general sweep of the hair around the ear and forehead. There's a patch of hair between each ear and eye that sticks up fairly straight, and can be rather thin and sparse; this patch is identified with the X marks. The longest, most noticeable hair inside the ear sweeps back, though the smaller hairs of the forehead sweep forward, up and toward the center of the head.

DRAWING FUR

When drawing fur, you can draw it in clumps (as seen in the drawing below, left). You may also find it helpful to use the pencil or pen strokes not to render the hair itself but to draw the empty spaces between clumps (below, right). There I indicated tufts of hair by emphasizing the dark space between the tufts (see the V-shaped details pointed out by the arrows).

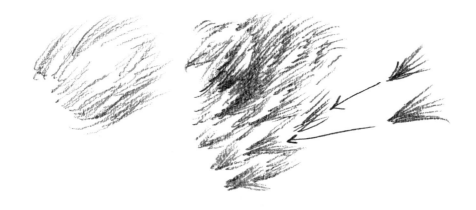

DRAWING SHORT HAIR WITH PENCIL

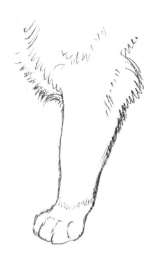

1 I began drawing a cat's front leg by defining the basic structure and coloration of a white paw on a black leg.

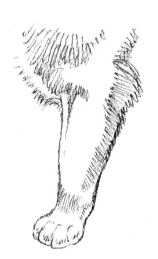

2 To start the leg shading, begin using long strokes to shade in some of the darker areas. Then use short strokes to begin defining part of the cat's toes. I didn't go to the very edge of the toes, leaving a blank area along the edges for lighter areas of reflective light.

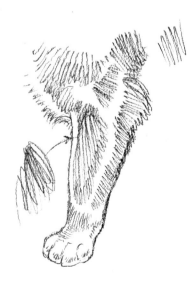

3 Next, shade more of the leg, using long looping strokes (see arrow) and a longer back-and-forth stroke up above. Continue to add short strokes on the paw and leave long streaks blank along the leg between shaded patches where the fur should look glossy.

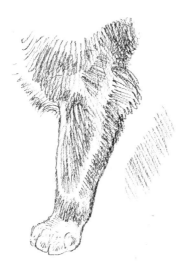

4 Go back over the entire drawing and use some softer shading to continue to add tone to the whole leg. Lightly shade into some of the formerly blank areas but still make sure not to shade them in too darkly. To the right, see the detail of the back-and-forth pencil strokes I used.

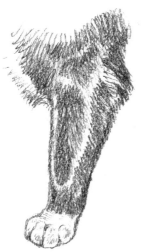

5 At this point, use short, thick strokes to continue shading in the leg, darkening it and defining the outlines. Leave highlights in the glossy areas relatively untouched, such as the area around the elbow that emphasizes a tuft of hair there.

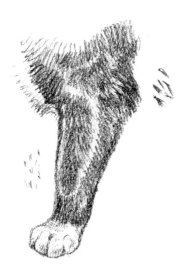

6 To finish the drawing, shade as needed, adding a few light strokes in the more highlighted area to keep the highlights from seeming too harsh or separate from the rest of the fur. Add some more details as needed, indicating areas where the fur clumps in small tufts. (Examples of the short, squiggly lines I used appear on either side of the leg.) Finally, draw soft, short strokes along the edges of the toes to add to their fuzzy appearance.

DRAWING LONG HAIR WITH PEN AND INK

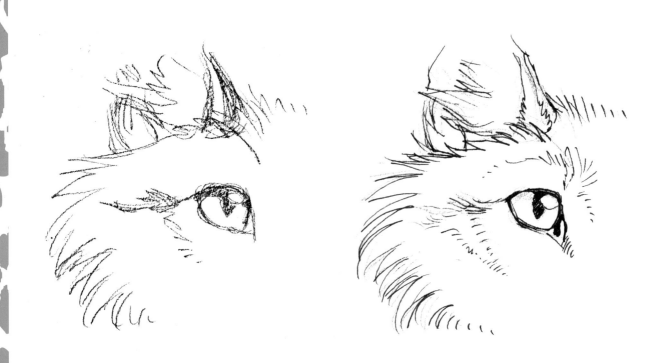

1 To begin, sketch out the drawing with a pencil.

2 Ink in the basic outlines of the cat's head, blocking in patches of fur to be defined later. Indicate the pupil and parts of the tear duct. Here I used a 0.5 pen.

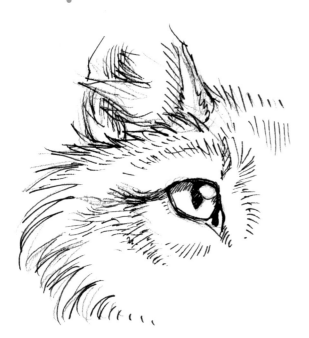

3 At this point, start filling in some short strokes to indicate hair, making sure the strokes line up with the direction of the fur. Add very short rows of fur near the ear and start shading in the ear a bit. Shade a little of the eye below the top eyelid.

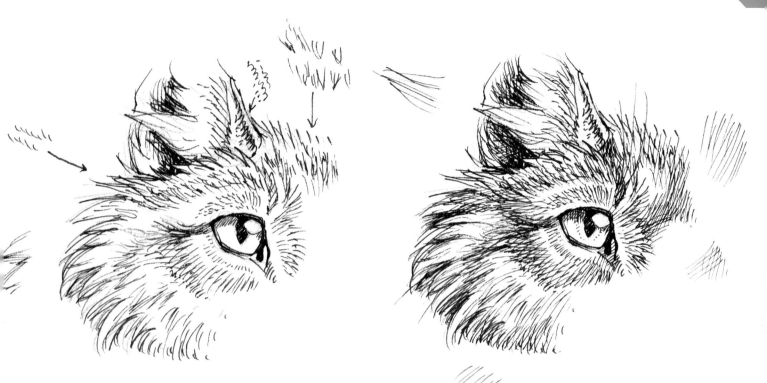

4 Adding details, draw very short strokes just above the eye to indicate the short, dense hair there. Create rows of fur radiating out from the top of the eye, some of which cross perpendicular to the rows of hair drawn earlier. Details of the kinds of strokes used appear near the various sections. On the forehead between the ears, bunches of V-shaped hair lines indicate more partings between different fur clumps. The hair is soft and short here, so keep the strokes short. Below the eye, use strokes to radiate out and shade more of that area as well. There's a bony ridge circling the eye. Keep ink lines short and dense to indicate where it curves in and meets the cheek. From there, draw longer strokes to indicate the long cheek ruff fur. Add clumps of fur with V-shaped marks interspersed with straighter lines. In the ears, add dark shadows in the center and some squiggly lines to show the dense hair just under the inner rim.

5 To finish the drawing, you can bring out a thinner pen. In this case, I used a 0.2 pen. Shade broad sections with the thinner lines, trying to bring all the shorter sections and clumps together with a wide swath of fur. Use the pen to fill in more shading at the nose and eyes and finish shading inside the ears. Also add whiskers and use cross-hatching on the nose, forehead, and ears for extra shading (see above right pen-mark detail). Leave a few small areas unshaded to keep a sense of light and prevent the drawing from becoming too cluttered and dark. For the finishing touch, add a little bit more shading and detail on the cat's eye around the pupil and do a little cross-hatching under the eyelid.

Chapter Two

KITTENS

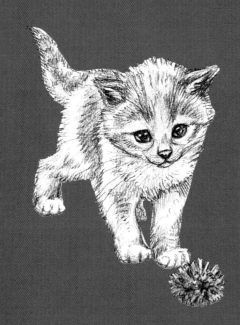

There are few things cuter than a kitten. Oversized heads, wide eyes, and an insatiable curiosity combine into an appealing creature for admirers and artists alike. When drawing kittens, strive for that sense of innocent playfulness.

KITTEN FEATURES

Kittens look like round blobs of fur sometimes, but they still have bone and muscle underneath all that softness. They have the same basic structure as any adult cat, though the proportions reflect the larger skull and sometimes long, gangly legs. They have a teeter-tottering, uncertain gait when young, because they're not quite as sure on their feet as an adult cat.

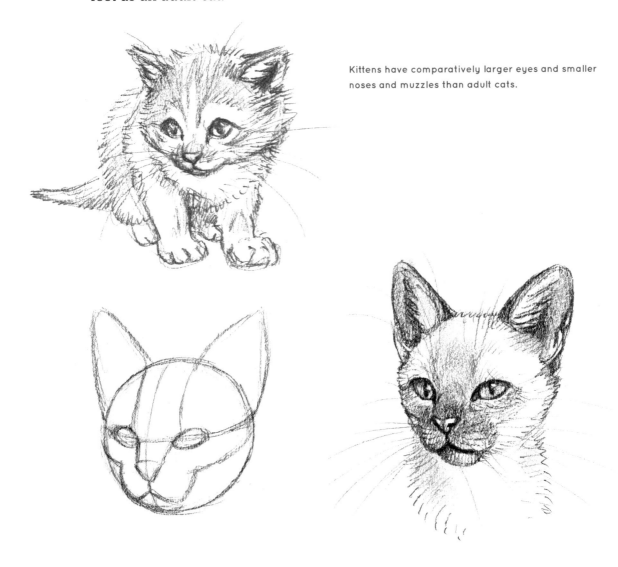

Kittens have comparatively larger eyes and smaller noses and muzzles than adult cats.

Here are the underlying shapes I used to block in the head of a Siamese kitten, along with the finished drawing at right. Note how rounded much of it is and how parts connect to one another. For instance, the shape of the nose extends up to meet the inside corners of the eyes. The muzzle comes up and then extends out under the cheeks. The invisible line that connects the spot above the kitten's eyes where whiskers are found extends up to meet the inside corners of the ears. The outside corners of the eyes stretch back to meet the outside corners of the ears.

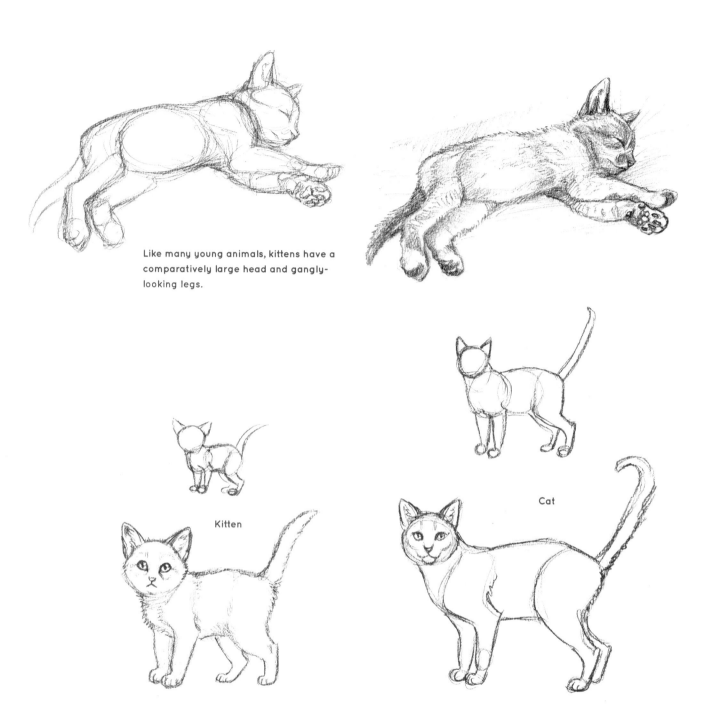

Like many young animals, kittens have a comparatively large head and gangly-looking legs.

Kitten

Cat

COMPARISON OF KITTEN AND CAT PROPORTIONS

Note how much larger the kitten's head looks in comparison to its body. In addition, its ears appear a little larger in comparison to its head. Note that the adult cat's muzzle is more developed and wider. The adult cat has longer legs, a longer body, and a longer tail. Its hindquarters are longer, thicker, and more developed than those of a kitten.

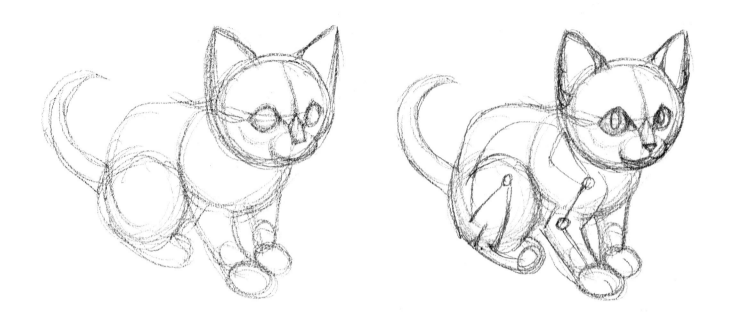

Kitten bodies consist of many rounded shapes. In this three-stage step-by-step sequence of a sitting six-week-old kitten, you see a comparatively large head set on other round shapes in the chest, paws, and hind legs. The second drawing also shows some of the basic skeletal structure.

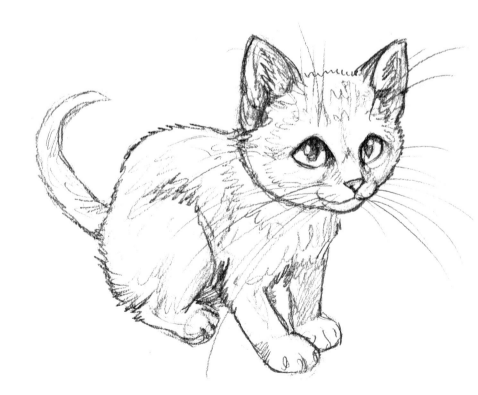

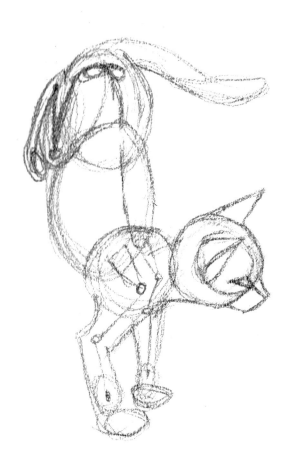

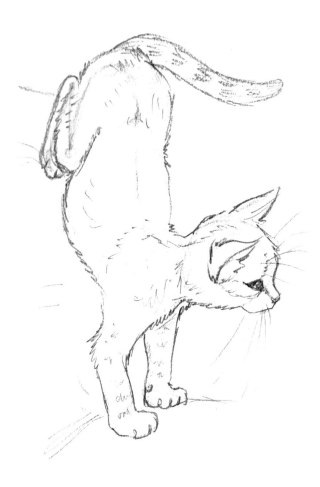

Like adult cats, kittens are flexible and agile. Note how the newly developing muscles in the legs support a flexible spine in this inquisitive kitten climbing over furniture.

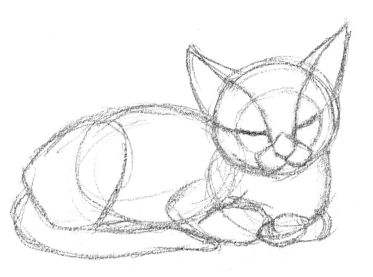

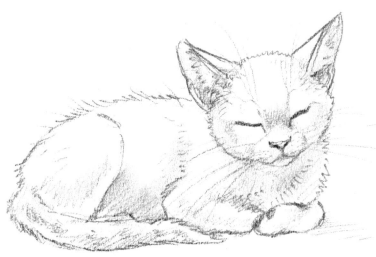

More rounded shapes are evident in this resting kitten, both in the sketch of blocked-in basic shapes and in the finished sketch.

THE PERSONALITY OF KITTENS

Kittens are curious and playful. When awake, they tend to be full of energy, always exploring their environment. It can be fun to draw them investigating every nearby moving object—including each other. Kittens are likely to try crouching and pouncing, but they don't quite have the coordination of an adult cat yet.

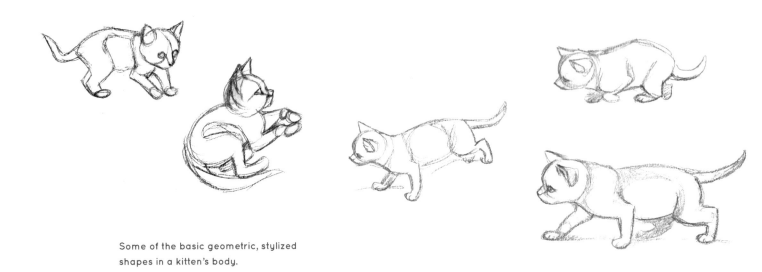

Some of the basic geometric, stylized shapes in a kitten's body.

These kittens are about four weeks old.

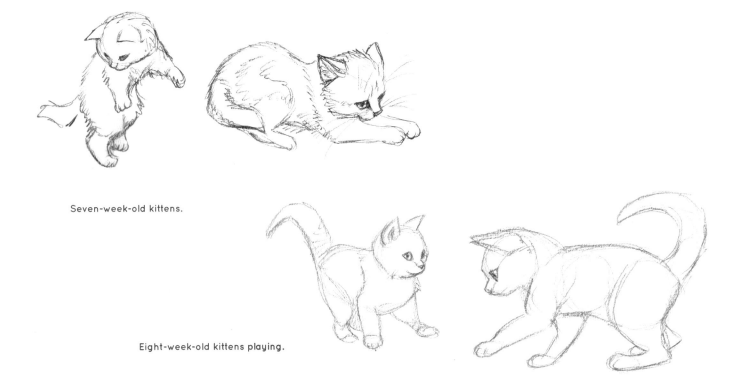

Seven-week-old kittens.

Eight-week-old kittens playing.

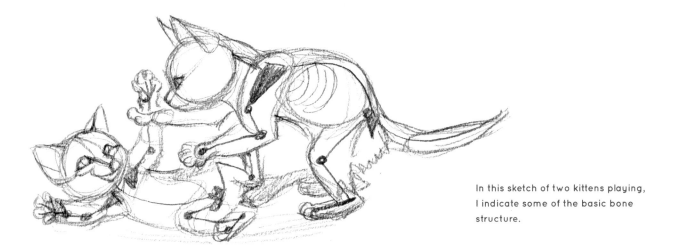

In this sketch of two kittens playing, I indicate some of the basic bone structure.

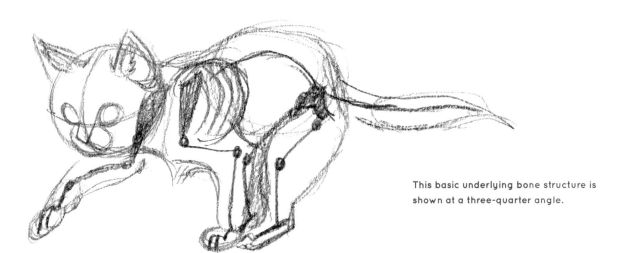

This basic underlying bone structure is shown at a three-quarter angle.

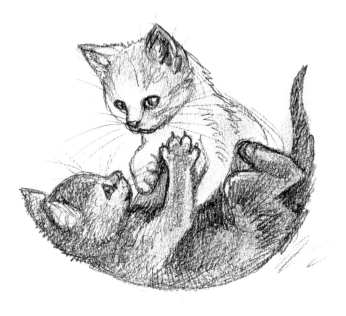

Two kittens wrestle and play with each other.

KITTENS FROM BIRTH TO SIX MONTHS

Kittens change rapidly from birth to six months of age. Here is a look at some of the features of kittens as they grow and become more coordinated.

NEWBORN TO THREE WEEKS

A mother cat has an average of two to five kittens per litter. The kittens' eyes don't open until they are about seven to ten days old, and their vision isn't fully developed until they're several weeks old. Young kittens' eyes may appear a little unfocused because of this. Their bodies are round and features like legs are comparatively small and underdeveloped. The ears are folded down at birth.

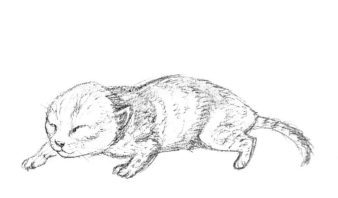

Note the closed eyes and folded ears of the newborn kitten.

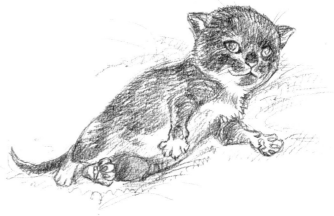

This kitten is one week old. Its eyes have opened but are still a little unfocused.

Two-week-old kitten. Its vision is still blurry but it has started to crawl around.

In both the sketch and finished version of this trio, you can see that by about three weeks of age a kitten's ears have grown fully erect. Kittens also will begin to walk around unsteadily at this age.

57

FOUR TO FIVE WEEKS

Kittens begin to develop more as they grow more active. Their legs become a little stronger, and they begin to leap and pounce.

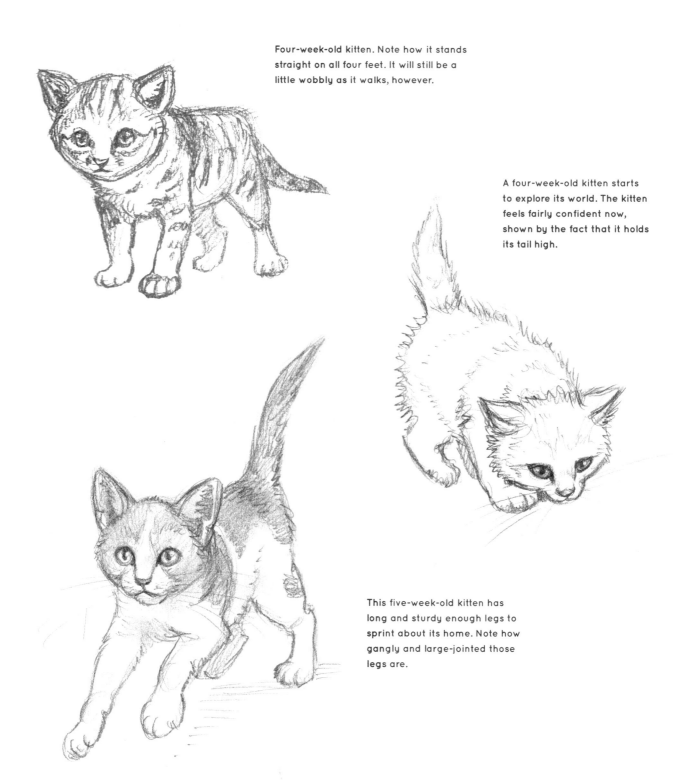

Four-week-old kitten. Note how it stands straight on all four feet. It will still be a little wobbly as it walks, however.

A four-week-old kitten starts to explore its world. The kitten feels fairly confident now, shown by the fact that it holds its tail high.

This five-week-old kitten has long and sturdy enough legs to sprint about its home. Note how gangly and large-jointed those legs are.

SIX TO EIGHT WEEKS

By six weeks old, kittens are full of energy. They actively explore their world. Their bodies are growing stronger, and they're beginning to look more like adults, except that their heads are comparatively large and their legs are still a little short and not completely developed.

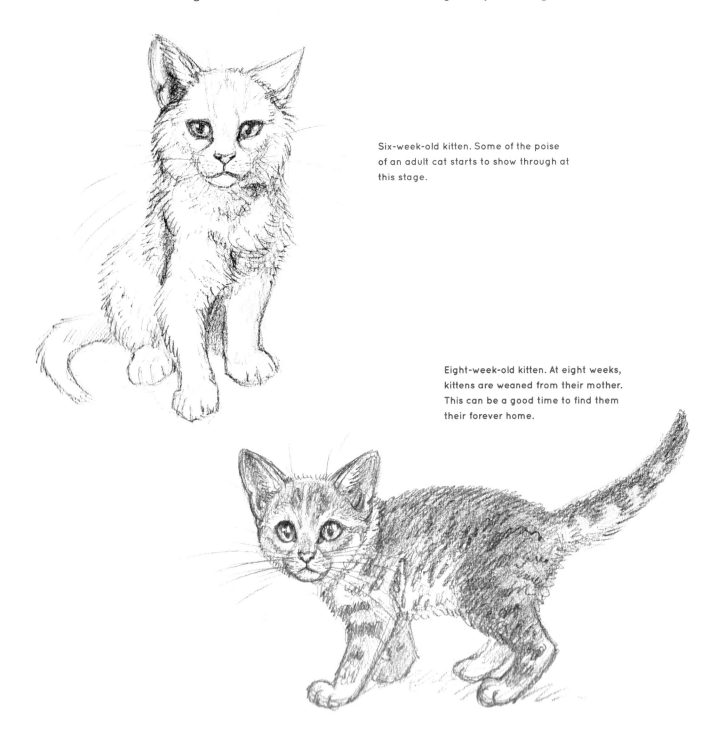

Six-week-old kitten. Some of the poise of an adult cat starts to show through at this stage.

Eight-week-old kitten. At eight weeks, kittens are weaned from their mother. This can be a good time to find them their forever home.

NINE WEEKS TO FOUR MONTHS

Kittens' legs are growing longer, and their feet seem comparatively big in relation to their bodies. They begin to fill out more but still have that big-headed, large-eyed look.

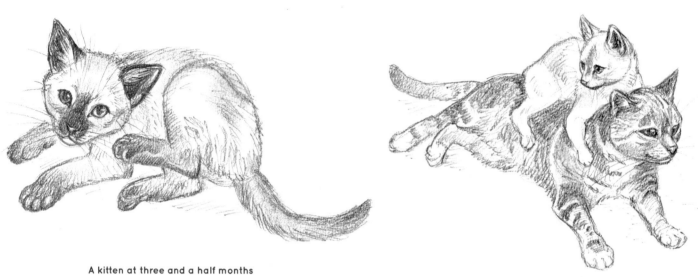

A kitten at three and a half months old. Its legs start to look gangly and comparatively longer in relation to its body than before.

This three-month-old kitten finds a perch on an adult cat, who seems quite tolerant of this.

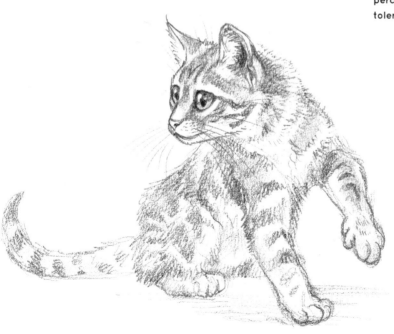

Four-month-old kitten.

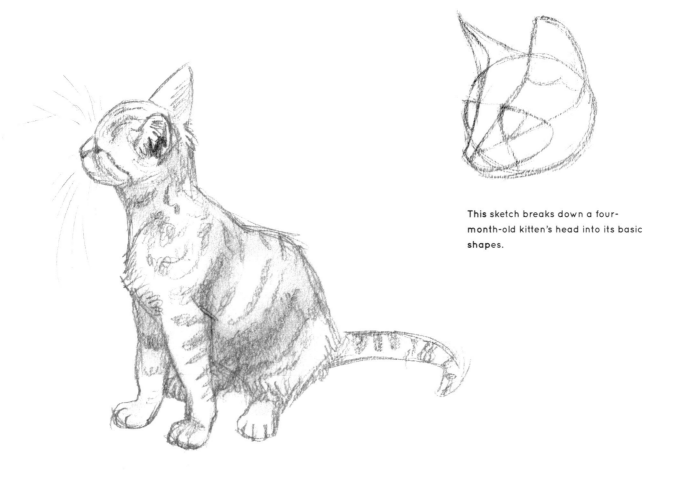

This sketch breaks down a four-month-old kitten's head into its basic shapes.

Four-month-old kitten.

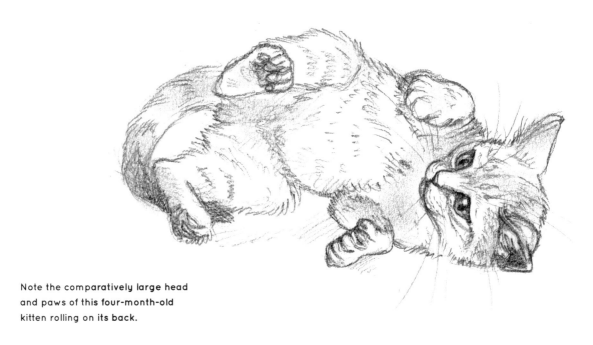

Note the comparatively large head and paws of this four-month-old kitten rolling on its back.

FIVE TO SIX MONTHS

By around six months, kittens are becoming adolescent cats, basically teenagers. They look like small, gangly adults that have slightly larger heads and eyes in comparison to mature adult proportions. The cat will continue to develop until it physically matures at around one year of age.

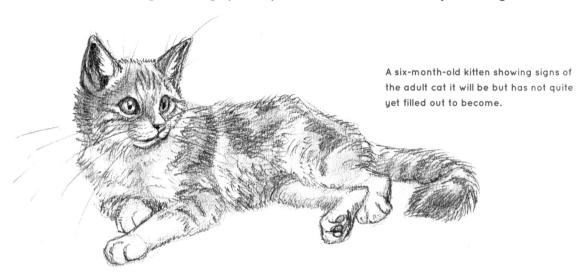

A six-month-old kitten showing signs of the adult cat it will be but has not quite yet filled out to become.

DRAWING A SIAMESE KITTEN

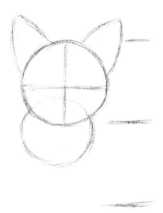

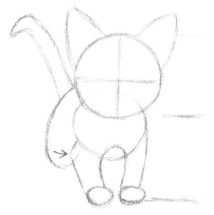

1 Draw a circle for the head. Draw horizontal and vertical guidelines that divide the circle into four equal quarters. Measure the length of the head circle, and mark the same measurement just below it so that you now have two head lengths to work with. Add a smaller circle overlapping, and below and slightly to the left of, the head circle to show where the chest will be. The bottom of the chest circle should extend about halfway down the second head-length measurement. Also go ahead and add triangular ears that start above the center of the head and don't quite meet at the top.

2 To create the front legs, draw a somewhat horseshoe-like shape in the middle of the chest to depict the inside of the legs, and then add the outside of the legs. The right leg and front shoulder, on the viewer's left, are angled slightly more toward the viewer and thus you can see more of them, including the hint of the elbow (indicated by the arrow). Draw ovals for the front paws, which should line up about at the bottom line of the second head-length measurement you made earlier. Then draw a somewhat vertical oval for the hindquarters behind the chest, and add the tail.

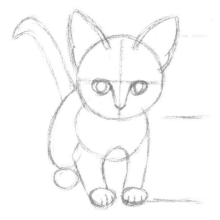

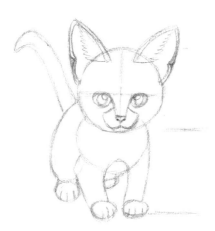

3 Add the eyes, aligning their tops with the horizontal guideline on the head. Draw the slanting nose between the eyes with something of a U shape that narrows at the bottom. Leave a little space for the mouth underneath. Draw the hind paw (a circle) under the hindquarter, and indicate the toes on the front paws. Draw the pupils and the rims of the ears, leaving a little double arch for the ear pocket in the inner edges of the outer sides of the ears. Draw the inside corners of the ears overlapping the outline of the head circle, coming down to meet the forehead a little below the very top of the head.

4 Add highlights in the eyes, and draw the muzzle, making sure the outside of the muzzle almost connects to the middle part of each eyeball before sweeping back inward toward the nose. Draw the chin along the bottom of the head circle. Define the nose pad, and add nostrils. Start indicating both the ear pockets and the inner tufts of hair inside the ears. Draw the toes on the hind paw, and make sure the paw itself is defined. Finally, add small circular shapes to indicate the farthest hind paw and leg under the chest.

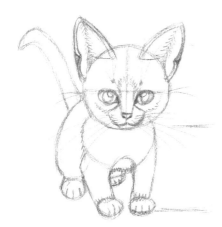

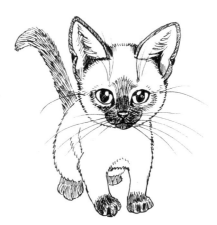

5 Finish the details of the Siamese kitten. Define the tear ducts of the eyes, and draw more hair inside the ears. Block in where the whiskers above the eyes will be. (I drew spots above the eyes and little toward the center of the face, and then drew whiskers coming from those points.) Add the whisker rows around the muzzle and the whiskers on the cheeks as well. Indicate where some of the darker markings will be on the cheeks below the eyes and the mask around the face. Block in the shading on the paws.

6 Now finish it by inking in the final drawing and then erasing (or deleting) the pencil marks. If you want, you can give the kitten other markings, too.

DRAWING A SITTING KITTEN

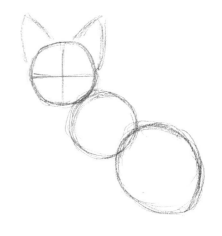

1 For this four-month-old kitten sitting in profile and looking at the viewer, start by drawing a circle for the head, another (about the same size) below and to the right of this for the chest, and a larger oval below and to the right of that for the rest of the body. Draw horizontal and vertical guidelines in the head circle to divide it into four equal parts. Then add the ears.

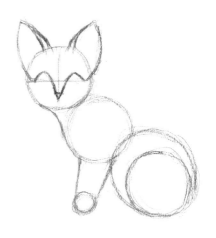

2 Begin blocking in some of the facial features, drawing the tops of the eyes and the pointed nose between them in something of an M-shaped mark. Leave room for the mouth under the nose. If it helps, connect the bottom outside corner of the ears to the outside corners of each eye to get an idea of placement. Add the inside corner ear rims. Draw the front leg: the front line should angle forward toward the front of the kitten slightly, while the back line of the leg should angle a little more steeply toward the lower body circle. Draw a circle for the wrist at the bottom of the leg. The bottom of the wrist should be about level with the bottom of the lower body circle. Draw a smaller circle inside the body circle for the hindquarters. Finish by drawing the neck, connecting the head and chest.

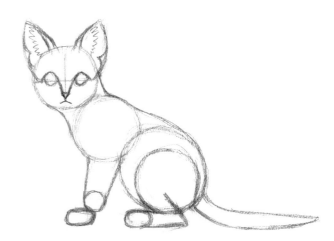

3 Draw the bottom of the eyes, and add a mouth. Indicate some of the tufts of hair lining the insides of the ears, and draw a triangular shape to suggest the ear pocket on the outside corners of the ears. Add the paws, drawing an oval for the front paw slightly forward of where the rest of the foreleg is. Draw the hind leg and heel, continuing up at an angle into the hind leg circle. This is where the leg folds in on itself. Add the tail, which should attach between where the hind leg circle is and the back. Fill in the back and back of the neck on the body.

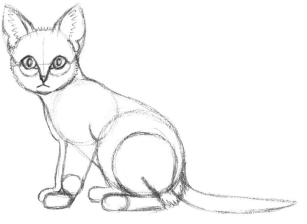 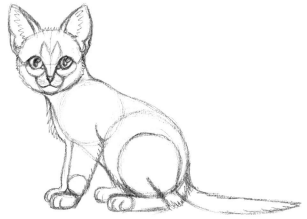

4 Add some more detail to the head, defining the furry top of the head and the cheeks. Add the pupils and tear ducts in the eyes, and block in the cheekbones under the eyes (this can help you place the muzzle later as well as help with markings on some cats, like tabbies). Broaden and define the nose if needed. Add the legs on the far side of the body. Note how the outline of the large body circle transitions into the far hind foot. Flesh out the wrist a bit as needed. Draw the elbow of the front leg, and add some of the fur on the kitten's rump below its tail where it sits on the ground. Also add the belly, connecting the chest to the stomach.

5 Finish most of the details. Draw the highlights in the eyes, and fill out the muzzle and chin (or leave it less defined, as in the previous step, if you want to keep it simpler). Draw the lines of the whisker follicles, and if desired, add the M-shaped mark above the eyes that tabbies often have. If nothing else, this M-shaped marking can help you block in the whiskers and the ridge of the brows later. Add some long, fluffy fur to the chest, belly, legs, and tail. Indicate toes on the paws.

6 Finish the drawing, placing the final lines and erasing the unneeded ones. Add the whiskers. If you want to experiment, try drawing this basic shape and then drawing different types of kittens: some with long hair, some with short hair, kittens with different fur patterns, and so on.

DRAWING A WALKING KITTEN

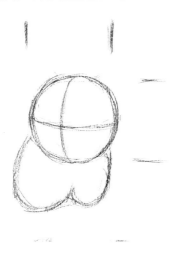

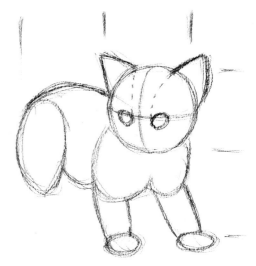

1 Draw a circle for the kitten's head, dividing it into four not quite equal quarters by crossing a slightly downward-curved horizontal line and a left-curving vertical line. This positioning will help create a three-dimensional appearance as the kitten looks slightly toward the viewer's left. Measure two head lengths down and two to the left. Then draw two humps under the head for the shoulders and two small ovals for the front paws, which should be placed just a little below the lower head-length measurement.

2 Add eyes to the head, keeping the majority of the eye ovals below the horizontal dividing line to keep the forehead looking large. Draw the far eye (the one to your left, the kitten's right eye) a little bit closer to the vertical dividing line. Since it's receding into the distance a bit, that side of the face appears a little smaller and more foreshortened compared to the other side. Add small ears. You can add dotted lines from the inside corners of the eyes to the inner ear bases if that helps, spreading the lines out slightly as you go up. Add the body, drawing a curved line for the back from just under the far ear base and looping down to make an oval for the hind leg. The distance should be about one head length (it should line up with the farthest left measurement line you measured out earlier). Draw a slightly rounded belly to connect to the shoulders. Connect the paws to the shoulders with slightly rounded tubes.

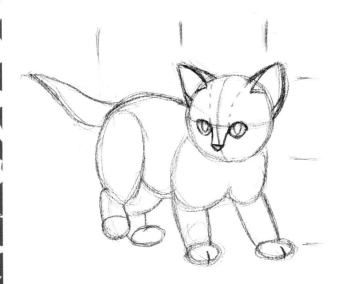

3 Add the nose, extending a line down from the inside corner of one eye to the pointed tip and back to the inside corner of the other eye. Complete the triangle of the nose pad. The nose should jut out just a little to the left, since the kitten's face is pointing slightly to the left. It will overlap the vertical dividing line, and in this case, the closer edge of the nose pad, on the right, is about even with the vertical dividing line. Leave a little space below for the mouth. Draw the pupils in the eyes, and add rims to the ears. Draw a line from the inside bottom ear rim to the middle of the ear. Add the hind feet. The near hind leg is lifted up, toes pointing to the ground. Also draw the far hind leg, both the hindquarters and paw, which is placed on the ground. Add a dividing line for the middle of the toes on the front paws. Since the kitten is moving at an angle toward your right, the toes are slightly pointed to the right and thus curve subtly in that direction. Draw the tail.

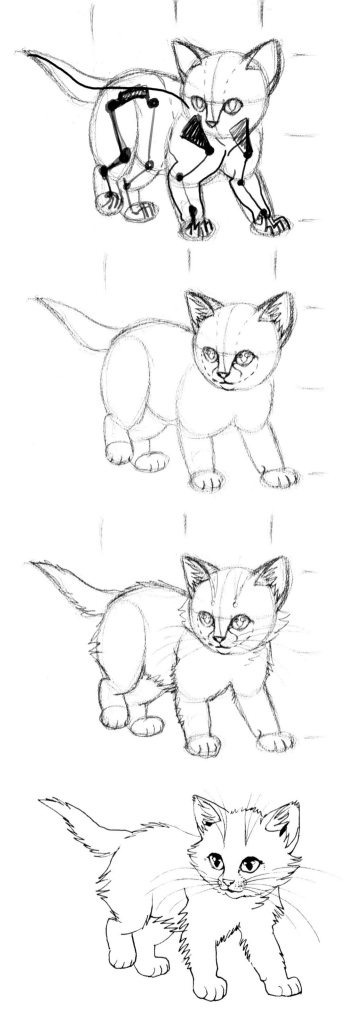

ANATOMY TIP: Here I've taken the drawing and placed some of the basic structure underneath to give you an idea of how the limbs are working at this angle.

4 Draw some highlights in the eyes and nostrils in the nose. Add a mouth and the tear ducts in the inner corners of the eyes. The corners of the lips can follow an imaginary dotted line from the lips around to the outside corners of the eyes (shown by the dotted line). Draw the top of the muzzle by creating a curved line sloping from the inside corner of the eyes down toward the chin. Draw the chin. Also add more tufts of hair inside the ears where they meet the head. Finish adding lines for the toes. Three slightly curved lines will indicate the four toes. Place the small dewclaw, which is visible just above the left front paw (the right paw in your view).

5 At this point, prepare the drawing for final inking by adding the fur. You can make it as short or long as you want. In this case, I made it medium length. The cheek ruffs and rump have prominent fur. Add whisker rows as well, and add whiskers if you wish to. Note that the clumps of whiskers above the eyes fall along the dotted line already in place.

6 Finish the drawing, inking in the final lines and then erasing the pencil lines underneath. I used a thinner line to draw the whiskers, making them seem more delicate. I also left little spaces between patches of fur or clumps of hair in a few places, which is a technique one can use to break up the line a little and create a more interesting drawing. Use it if you wish. Of course, if it is a computer drawing or will be scanned in and colored on the computer later, keep all your lines solid for greater ease of filling in color.

SHADING STEP-BY-STEP

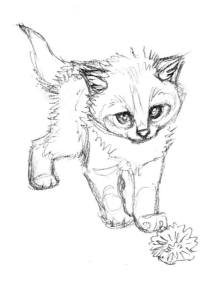

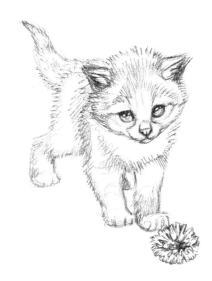

1 This young kitten is about four to five weeks old and just starting to really explore its environment. In this slightly more advanced demonstration, I'll cover how I shade and add detail to a drawing. To start, first I blocked in the basic shapes and details of the kitten I wanted to draw.

2 I went back over the drawing, adding the main details and outlines of the fur using short, choppy strokes where there was a flat, fuzzy flank or other broad area. I added some shading under the upper eyelids, defining the main highlights in the eyes, and details in the eyes, nose, and the toy the kitten is looking at.

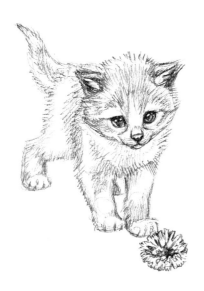

3 I went back over the drawing and kept adding details, fur, and shading (such as to the tail and under the legs and body). I added the pupils and the whisker follicles.

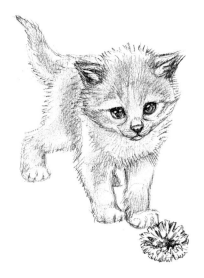

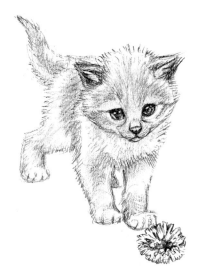

4 At this point, I smudged the pencil lines with my finger (though you can use a smudge tool as well). Most of the kitten's body is at least a little smudged over, except for the brightest white parts.

5 I went back with a kneaded eraser to erase a fine line along patches of lighter fur, creating some white lines in smudgy gray areas to bring out the appearance of tufts of fur.

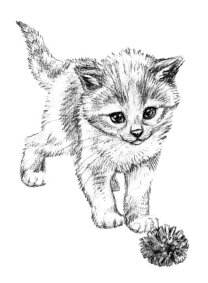

6 After smudging and erasing, I went over the drawing again with my pencil to tighten up the detail. I made sure there were outlines where I needed them, but left breaks in the outlines: white spaces here and there to keep the fur looking light and fluffy. I smudged the toy and then added a little pencil detail again as needed. I drew some shadows in the fur where clumps of hair break apart on the chest, the top of the head, and other areas.

Chapter Three
CAT EXPRESSIONS

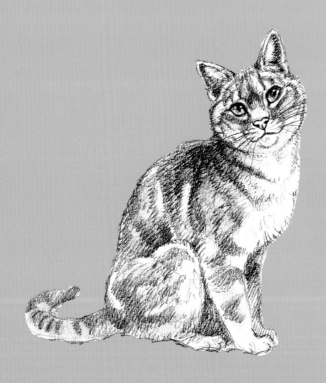

Cats can be a little less subtle in some of their expressions than we or, say, dogs are, but they definitely have "looks" that help convey and communicate to others what they are feeling or thinking. Some are dramatic, like a defensive, hissing cat. Some are less obvious, like the slow blink of a contented feline. Knowing cat expressions can help you convey their mood and personality.

HAPPY AND CONTENT

A happy cat looks relaxed. Its tail may be held relaxed or pointed high up as it meets a friend. It walks in a confident manner, head held high. It may greet a human or another cat with head, body, and tail rubbing. Cats tend to meow to humans more than to other cats. It seems to be their way of communicating or greeting us. If sitting or lying down, a cat may close its eyes or do a slow blink, which indicates the cat is comfortable and trusts those near it. Its facial muscles will be relaxed, not taut.

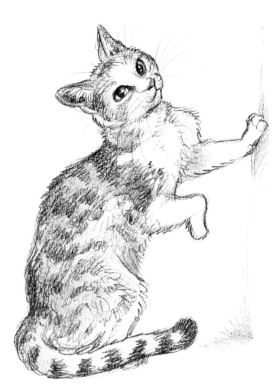

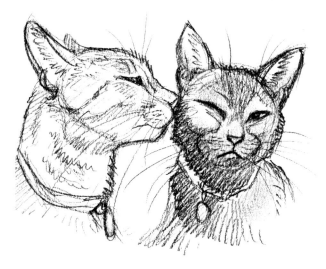

These two cats are comfortable with each other. Their ears are relaxed, and their eyes are closed or nearly closed. It's possible that the one on the right might be slightly annoyed by his friend sniffing in his ear, but he doesn't feel threatened.

This cat is relaxed. He sits with his paws tucked neatly underneath him, tail resting on the floor, quietly watching the world around him. His head tilts with mild curiosity, and he observes things with a neutral, tension-free facial expression.

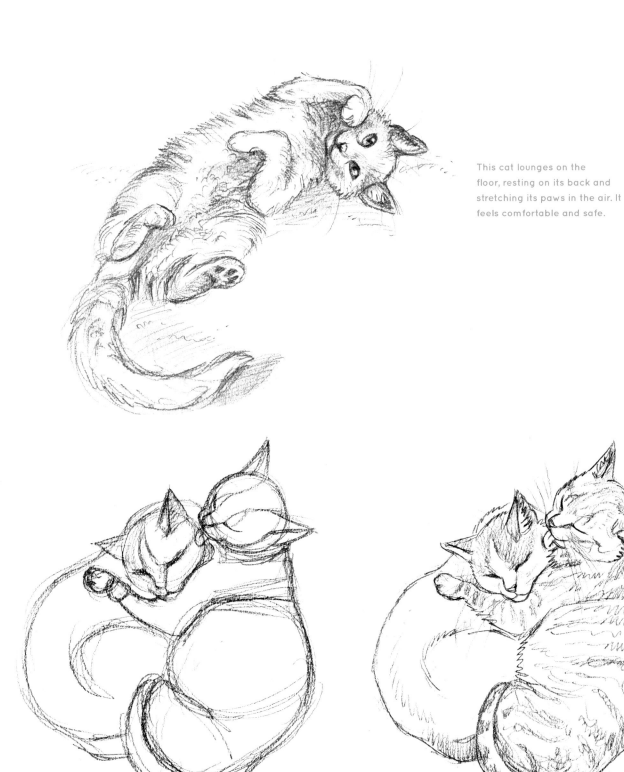

This cat lounges on the floor, resting on its back and stretching its paws in the air. It feels comfortable and safe.

In both the blocked-in sketch showing some of the basic shapes I used to draw these two cats (above) and the finished drawing (right), these two are obviously comfortable with each other. Notice the relaxed ears, neither pricked forward nor flattened back. Two cats would not nestle together like this, belly to belly, a paw draped over the one being groomed, unless they were familiar with each other. With eyes closed, these two felines act affectionately and trustingly.

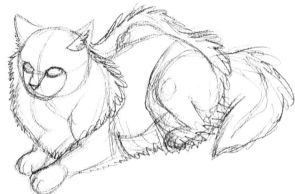

1 Here I drew a relaxed cat lounging around, feet tucked neatly underneath it. Its long hair ultimately obscures a lot of its form, which I've indicated here.

2 Here, I've gone back over that form, re-emphasizing the thick waves of fur hanging from the body. The thick neck ruff envelops the neck and overlaps the shoulders, and the fur on the hind leg overlaps and hides the foot.

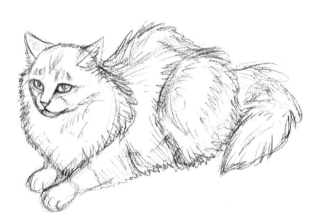

3 I lightly erased some of the lines of the form so that it would be easier to continue working on. Then I started adding more definition to the long fur and putting in details like the pupils, toes, nose, and mouth.

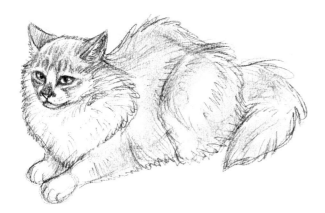

4 At this point, I added more shading and detail to the face, erasing more guidelines as needed. I also smudged most of the body to darken the fur, except on the white nose and throat "bib."

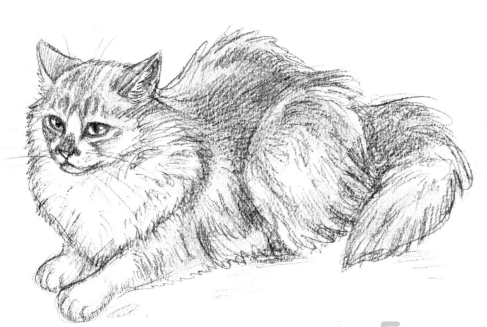

5 Here, I finished the drawing by adding more details to the fur, whiskers, and shading where appropriate. Some of that shading was darker tones between clumps of fur on the hindquarters, back, sides, and neck.

ANGRY OR DEFENSIVE

A cat that feels defensive or aggressive is not relaxed. Its body may be curled in, head low and back arched. The tail might be curled under its body (for a very frightened cat) or sticking straight up with hair standing on end. Sometimes, its tail may swish back and forth rapidly. It may use its claws to try to swipe at a threat. A defensive or aggressive cat's ears will be flattened back behind its head.

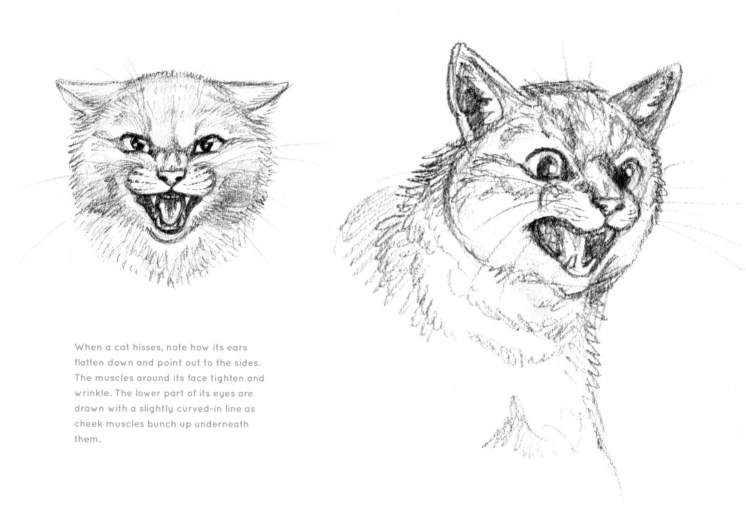

When a cat hisses, note how its ears flatten down and point out to the sides. The muscles around its face tighten and wrinkle. The lower part of its eyes are drawn with a slightly curved-in line as cheek muscles bunch up underneath them.

This hissing cat looks to be a little uncertain. Its ears remain more upright as it listens for possible danger.

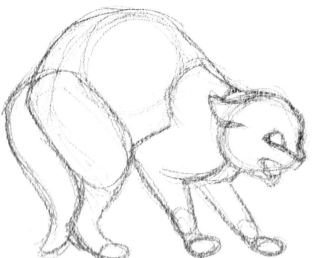

This cat arches its back in a defensive posture, keeping its head low. Its tail is tucked down near its body.

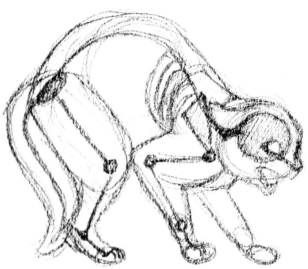

In this version of the same pose, I show some of the underlying basic anatomy. The back arches dramatically.

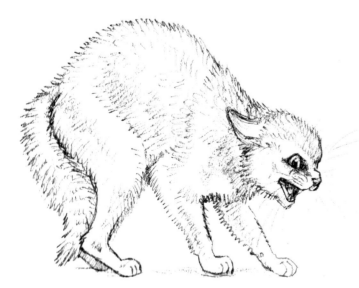

In the finished version of this defensive, hissing cat with an arched back, note the "bottlebrush" tail. The cat's hair is raised on end to make its body and tail look larger. It is fearful and prepared to fight to protect itself. The next step would be to lash out with extended claws. An angry cat might also stick its tail straight up.

DEFENSIVE CAT VERSUS RELAXED CAT

Here are two different open-mouthed cats. One is defensive, and the other is simply yawning a bit. There are some key differences in their facial features that are important to know when trying to depict each expression.

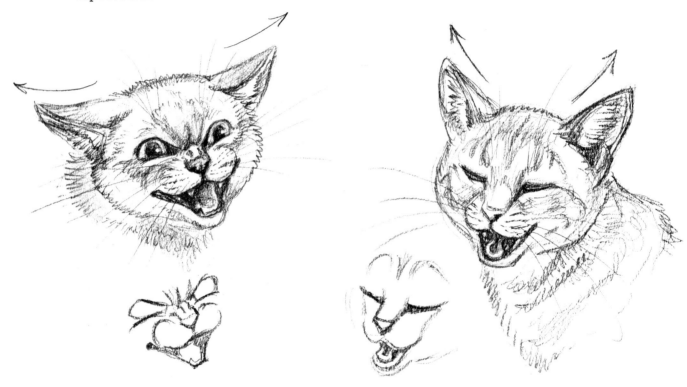

The cat here feels threatened and is hissing. Its face is tense. The muscles are furrowed down and wrinkled above its nose, on its eyebrows, and on its cheeks. There's a lot of tension around the eyes and muzzle, indicated by darker, slightly overlapping lines in my drawing. The cheeks push up against the eyes. The ears flatten to either side (shown with arrows). The eyes themselves have dilated (enlarged) pupils. A stressed, frightened cat may often have dilated pupils even in broad daylight. A more aggressive, angry cat may often have constricted (smaller) pupils. (The smaller drawing shows a simple version of this cat's expression.) Lines are sharp, pinched in together, and the mouth is spread wider in what almost appears as a grimace.

The cat here is much more comfortable. Its mouth is open, but it is yawning; its tongue is curled at the tip, and its mouth is relaxed, not stretched wide. Note how the ears are more upright, not flattened down (shown with arrows). The eyes are mostly closed, and there is little tension there. The nose, cheeks, and brows are all relaxed, and there are no crinkles or furrowed lines. One thing to note, however, is that sometimes animals yawn when they're a little bit stressed. If the cat's ears were swiveling more, or there were more tension on the face, this could indicate a more uncertain feline. Another thing to be aware of is that a defensive cat may keep its ears pricked forward even as it hisses, if it's trying to remain alert to a perceived threat. (The smaller drawing emphasizes some of the most basic shapes of the stress-free cat's face.)

CURIOUS

Curiosity killed the cat but satisfaction brought it back, goes an old saying. How do you indicate curiosity? A curious cat investigates its surroundings with wide eyes, staring fixedly on the object of interest. Its ears prick forward, and it may raise a paw to bat at the object or try to hook it with a claw to draw it closer.

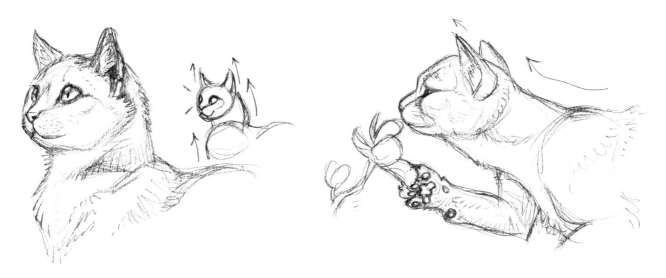

This cat shows the classic signs of curiosity: bright, wide-open eyes and ears pricked forward. It is trying to ascertain what something is and is using its senses of hearing and sight. Its head is lifted high and confidently.

This curious cat uses its claws to pull a plant closer so that it can use its sense of smell to investigate it. Note the forward-pricked ears and how the cat is leaning in toward the object of its investigation.

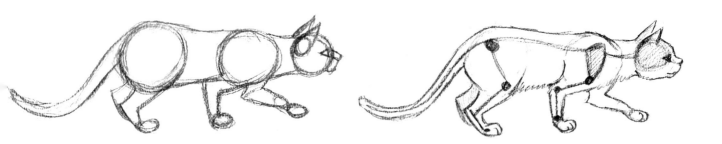

This cat shows classic curiosity combined with some stealthiness. It stalks, creeping toward an object of interest, keeping its body and head low, tail dipped. Its ears are pricked forward. It could try to pounce on something, or perhaps it's simply trying to get a closer look. Another sign of predatory behavior in a cat is a tail held low with a tip that twitches excitedly back and forth.

This version of the drawing shows the simplified skeletal structure of the cat as it creeps forward.

UNCERTAIN AND SURPRISED

A cat that feels uncertain has not yet committed to any one course of action, and so its expression may reflect conflicting emotions or intentions. A fearful or agitated cat's tail may swish in wide arcs from side to side.

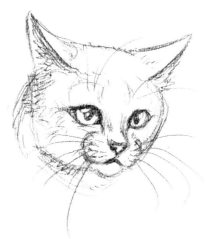

This cat is uneasy and possibly a little frightened, but it is still trying to assess the situation before reacting. Its eyes are wide, looking a bit alarmed. Its mouth is closed. Some tension in its face makes the upper lips/muzzle a little bit taut, almost puckered. The cat's ears swivel around. One pricks up in a more neutral position, but the other swings and flattens to the side. In this cat's case, it was being picked up and was unsure how to react at first, but it soon returned to a more neutral expression as it realized everything was okay.

This cat is also rather unsure about its situation. Like the other cat, it exhibits no dramatic displays, such as a hissing mouth or flattened ears; however, its ears swivel backward, and its upper lip is slightly puckered. Even its whiskers are bristly and spread in many directions. This cat's eyes are wide as it uses its vision to ascertain its surroundings. The head is also held a bit low, which is more defensive.

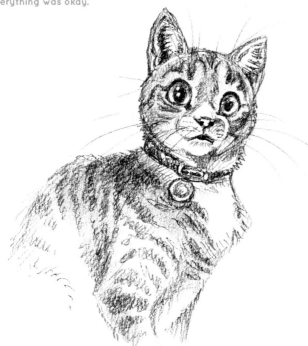

This cat looks a bit surprised due to the wide eyes and the tensed, curled lip. The tabby markings on the face almost substitute for raised "eyebrows," adding to the shocked look.

PLAYFUL AND FRIENDLY

A playful or friendly cat is at ease with its surroundings and company. Ears will be pricked up, probably forward. Its tail may be lifted high with a definite curl to the tip or middle. It may rub against a companion, whether another cat or a person, and lightly curl its tail on him or her. It may also lie on its back with paws in the air.

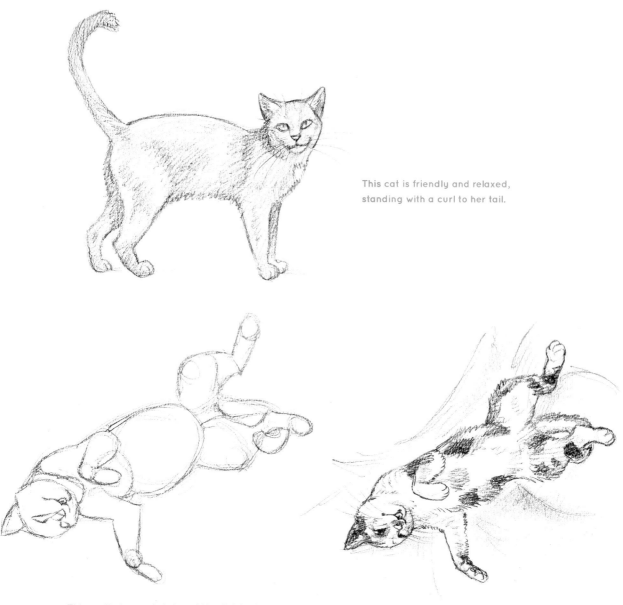

This cat is friendly and relaxed, standing with a curl to her tail.

This preliminary sketch and the finished version at right show a friendly feline relaxing on its back. A cat that does this next to a person may be seeking attention and affection, though unlike most dogs, cats don't usually seem to enjoy people rubbing their belly. A few do, but many may bat a human hand away for trying it.

Chapter Four

CATS IN MOTION & AT REST

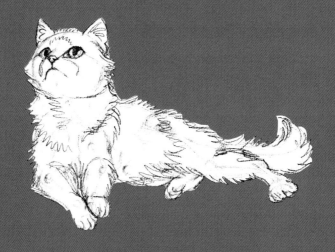

A standout feature of cats is how graceful they are, whether moving or just sitting still. They move through their world with coordination and balance, seemingly effortlessly walking on top of a narrow fence or almost always landing on their feet. They have a curved, delicate, sensual appearance coupled with steely strength that comes out with bared teeth and claws should the need arise. There are many ways to approach drawing a cat, and here, I'll look at a few techniques. Explore, experiment, and find what works best for you.

BREAKING DOWN STRUCTURE

It can help to break down the form into various shapes, such as bones, boxes, circles, cones, and ovals, that help you block in that form and visualize how it's put together. You may find it helpful to draw the underlying skeletal structure of a cat, with basic bones and joints included. Knowing the skeletal structure helps you understand the bones, and then the muscles and tendons underneath the fur, that affect what you see.

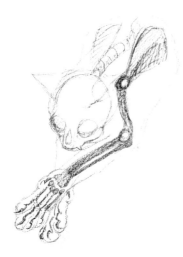

A look at some of the underlying bone structure.

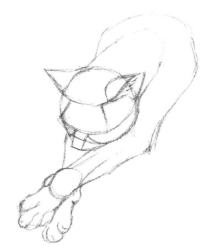

Some of the basic geometric shapes these bones and muscles help build.

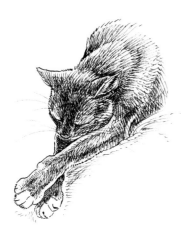

The finished drawing shows how the cat actually appears.

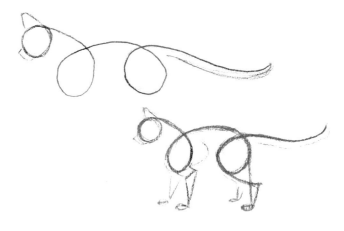

Here's a way of drawing a cat's body in one long, looping line joined by some extra lines to define the legs and muzzle. Note how the hind legs can be drawn by crossing together at the heels, using one almost straight line starting from the rump and one curved line sweeping from the front of the hind legs. The cat's body looks a bit like a coiled spring ready to pounce. This breakdown isn't perfect and is best used as a guide. For instance, drawing the shoulders as part of a loop like this can make them seem more shrunken down than they are. In reality, a cat's shoulders can sometimes be quite prominent on the outline of its back, especially if it's crouched or stalking.

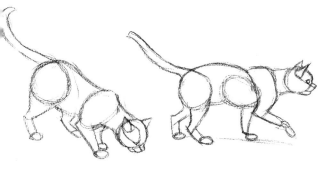

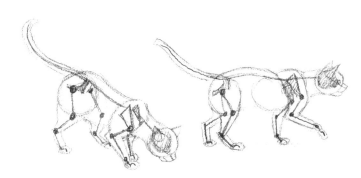

If you have a little more familiarity with the skeletal structure of cats, it may be helpful to draw like this, using basic shapes, such as circles, ovals, and cones, to make up the body. In this method, cats are drawn with shapes that often flow into one another. Note how the line of the back loops around to form the hindquarter and then connects to the top line of the tail. Also note how the shoulder arcs along the curve of the rib cage and abdomen.

Here I've shown the basic skeletal structure in cats in the same poses as at left to help you further visualize how the cat's body is put together.

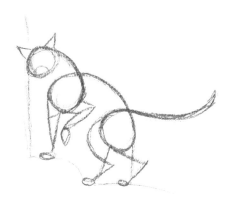

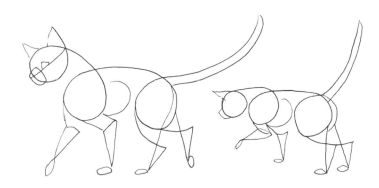

The example above, left, shows a cat rubbing up against something and drawn with connecting and looping lines. Note how the sweep of the chest blends into the front legs and how the hind legs arc up into

the tail. The two sketches above, right, use the same method of breaking down the form, this time showing cats walking.

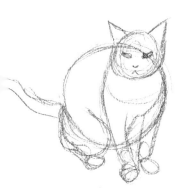

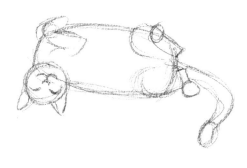

When breaking down the form, also look for basic overall shapes. Sometimes almost the entire body may fit into some basic shape, like a circle (left) or an ellipse (right).

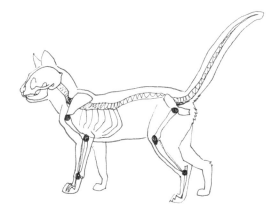

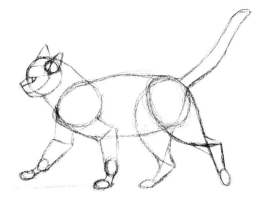

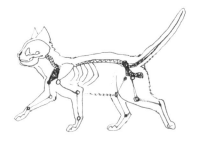

Once you have the knowledge of the basic skeletal shapes, you can stylize the form in whatever way helps you visualize it best. It can be fun to experiment and draw out exaggerated, stylized shapes to help you understand the form better. This drawing is a look at some of the more geometric shapes in a cat's body in the same pose as the second drawing at left.

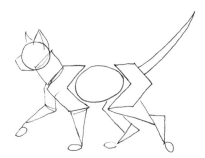

These forms show some of the skeletal structure inside the cat body. Note how the bones remain connected but can rotate in their sockets or joints to propel the cat into motion.

Here you can compare two different ways to approach building the same pose.

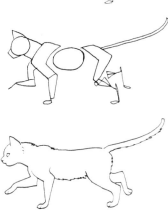

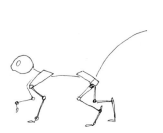

The geometric shapes are even more pronounced here. Note how the shoulder and hip look like mirror images of each other.

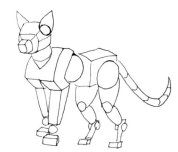 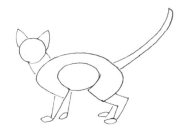 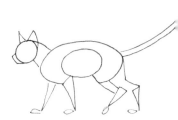

These geometric breakdowns are even more stylized, using shapes to explore the cat's form. Experiment with these methods or find your own.

ACTION LINES

Another thing to keep in mind is the general direction of movement in a form. Action lines can help you visualize the main thrust of movement in the cat body. An action line is drawn as a line that flows through the body. First determine the line of action, then draw the form to accentuate it. You can adjust as necessary until form and action look right to you.

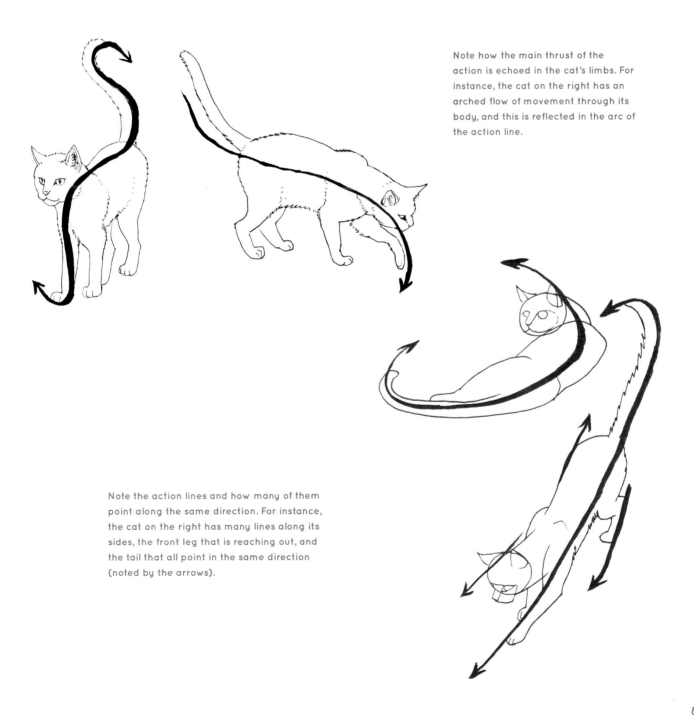

Note how the main thrust of the action is echoed in the cat's limbs. For instance, the cat on the right has an arched flow of movement through its body, and this is reflected in the arc of the action line.

Note the action lines and how many of them point along the same direction. For instance, the cat on the right has many lines along its sides, the front leg that is reaching out, and the tail that all point in the same direction (noted by the arrows).

COMPLETING THE FORM

You can use all the shapes and guides just shown to help you finalize the drawing. Take a look at the progressions here, from breakdown sketches to finished drawings.

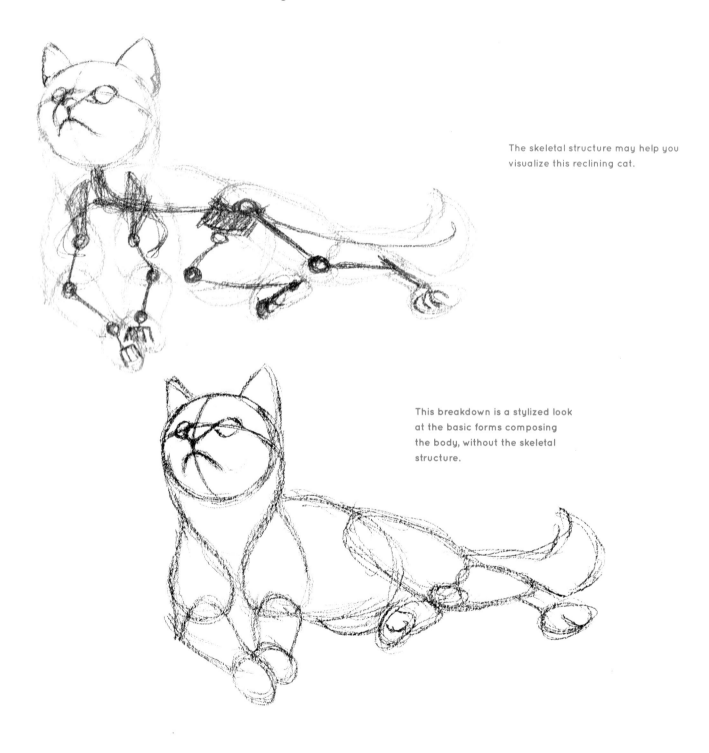

The skeletal structure may help you visualize this reclining cat.

This breakdown is a stylized look at the basic forms composing the body, without the skeletal structure.

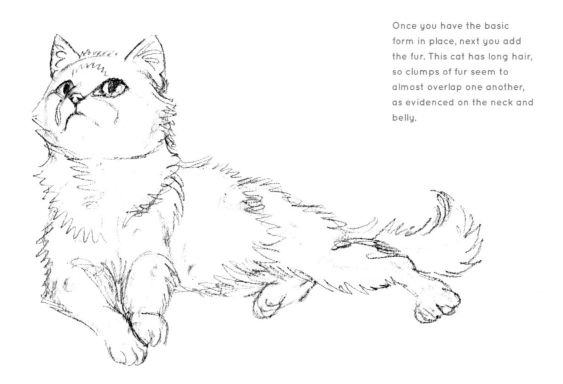

Once you have the basic form in place, next you add the fur. This cat has long hair, so clumps of fur seem to almost overlap one another, as evidenced on the neck and belly.

For the final drawing, more details are added to complete the form.

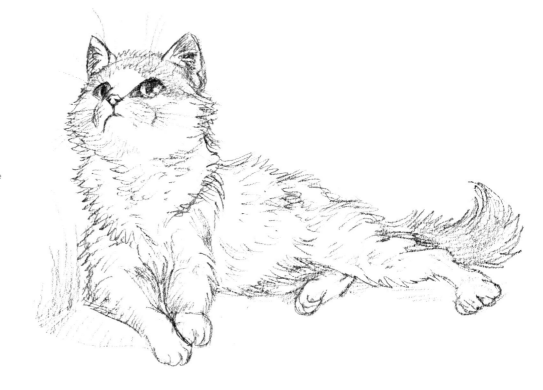

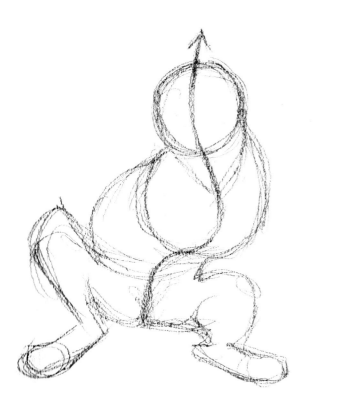

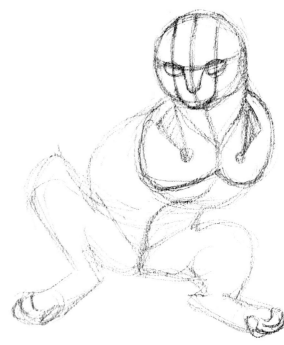

Here, I show some basic steps of drawing a cat sitting in an almost human-like pose. First, I block in the basic form of the body and hind legs, emphasizing the deep chest, which juts forward and then bends down in a bean shape to meet the sprawled-out hind legs. I've also drawn the action line, which bends along the torso and comes out through the top of the head.

Next, I add more facial features, making a U shape on the head that helps block in the shape of the muzzle and helps with ear placement later. I also draw the shoulders in a very curvy, almost W shape. I add the shoulder blades as a guide as well. Then I draw the hind toes and paw pads.

Now I add the front legs, using the shoulders as a base and going from there. I include more of the skeletal structure to show how the legs are constructed. I add the ears, using the U shape on the head to continue the lines up as the inner corners of the ears, around, and connecting the outside corners of the ears to the horizontal eye line on the head. Then I add the tail.

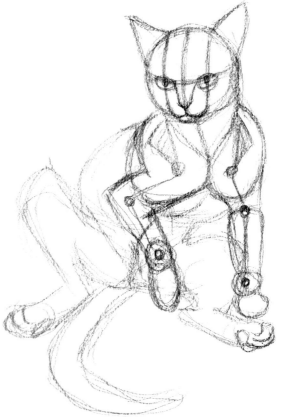

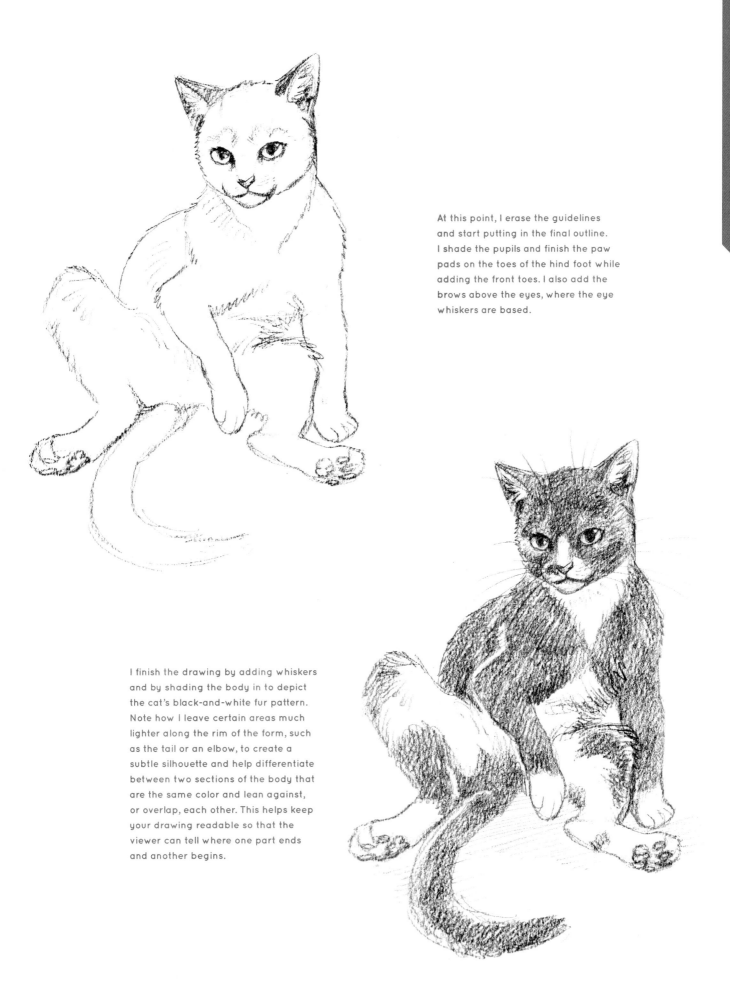

At this point, I erase the guidelines and start putting in the final outline. I shade the pupils and finish the paw pads on the toes of the hind foot while adding the front toes. I also add the brows above the eyes, where the eye whiskers are based.

I finish the drawing by adding whiskers and by shading the body in to depict the cat's black-and-white fur pattern. Note how I leave certain areas much lighter along the rim of the form, such as the tail or an elbow, to create a subtle silhouette and help differentiate between two sections of the body that are the same color and lean against, or overlap, each other. This helps keep your drawing readable so that the viewer can tell where one part ends and another begins.

COMMON CAT ACTIONS
GROOMING

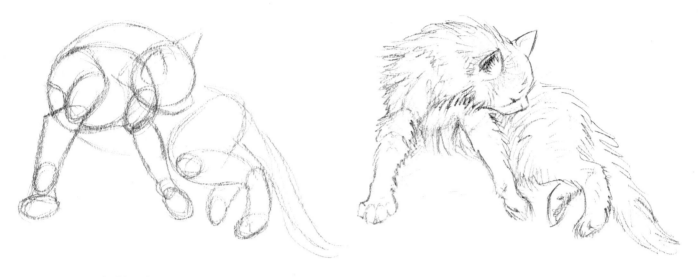

As this cat grooms itself, note how the front legs are like tubes sticking out from under the shoulders.

The finished sketch of a grooming cat. The underlying structure is less visible beneath the fur and overlapping physical form but remains the same.

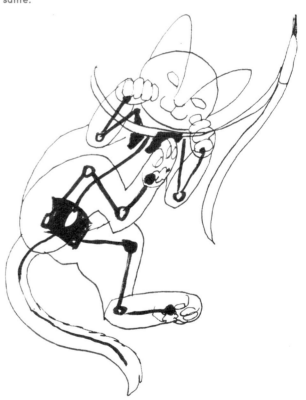

PLAYING

A look at the skeletal structure of a young cat playing. Keeping the relation of shoulders and hips in mind helps when drawing a cat rolling about on the ground. Legs may rotate and stretch out, the spine may twist some, but shoulders and hips keep the same distance on the spine.

STRETCHING

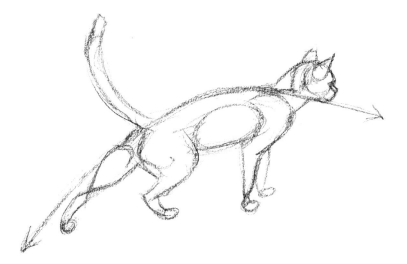

An action line shows the main movement of this stretching feline. I used loose shapes to mold the cat's gesture together.

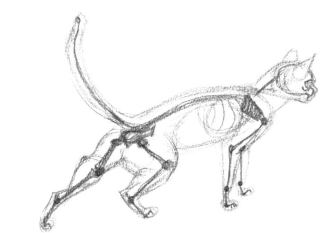

Here is a look at the skeletal system that holds all these shapes together.

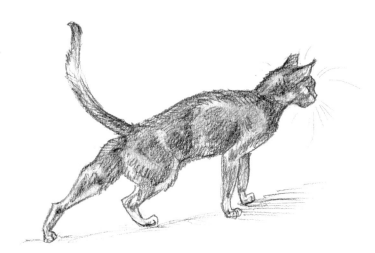

The final drawing of the stretching cat. The cat is more detailed and realistic, but the essence of its arcing stretch remains clean, clear, and easily readable.

FOCUSING

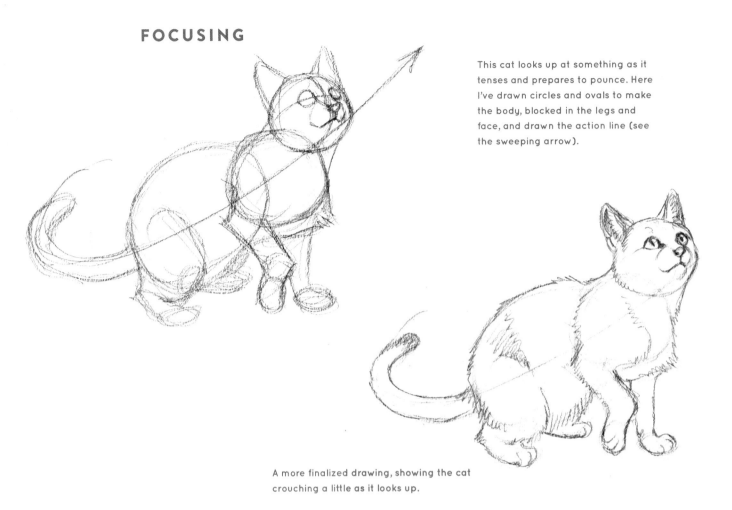

This cat looks up at something as it tenses and prepares to pounce. Here I've drawn circles and ovals to make the body, blocked in the legs and face, and drawn the action line (see the sweeping arrow).

A more finalized drawing, showing the cat crouching a little as it looks up.

SMELLING

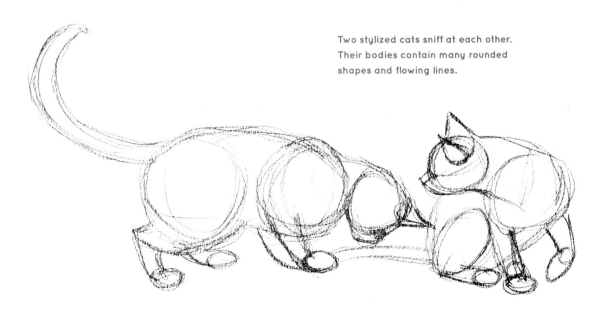

Two stylized cats sniff at each other. Their bodies contain many rounded shapes and flowing lines.

LOUNGING

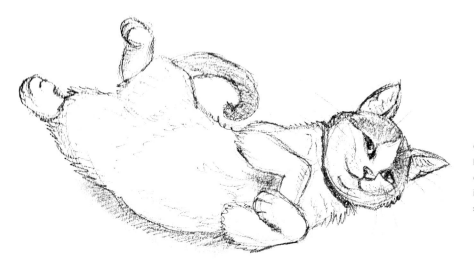

Cats have incredibly agile, limber bodies and can roll around or lounge on their backs in positions that make it look like they hardly have a skeletal structure inside...

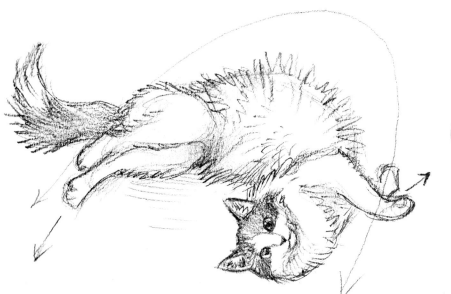

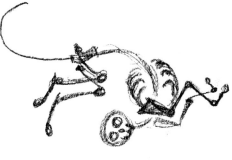

...Yet they do have skeletons—just ones that can let them twist around in what almost look like contorted shapes. At left is the cat with an action line and at right is the basic skeleton of that cat, lying on its back with limbs twisted one way and then another.

STALKING AND CREEPING

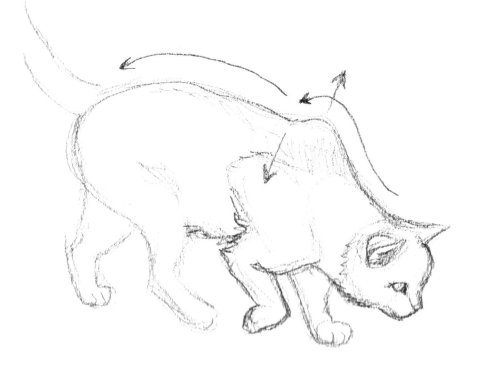

Keep this in mind when drawing a creeping cat: one front paw remains on the ground and one lifts as a cat steps forward. The shoulder of the leg that is planted on the ground will jut upward, creating the pronounced bump on the outline of the back (see the long, flowing arrows over the back in this drawing). The opposite shoulder, the one on the side with the paw in the air, will drop down more. In this drawing, the cat supports her weight on her left front leg, the far leg. The arrow above it highlights how that shoulder juts into the air. The downward arrow highlights the near shoulder, the one that isn't supporting any weight as the cat steps forward and so sags down somewhat.

Here I've shown the basic skeletal structure to give you a better idea of how the legs and joints are working in this pose. Note the near shoulder blade drooping down and the far shoulder, which is part of the leg supporting the weight (which is thus straighter and more extended).

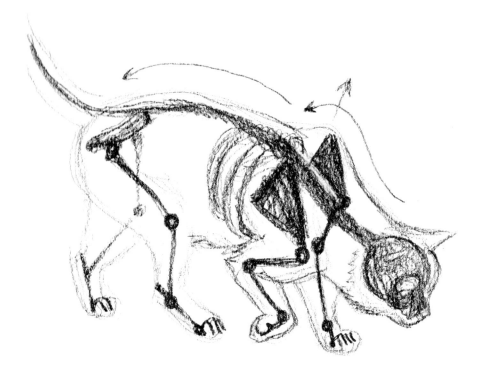

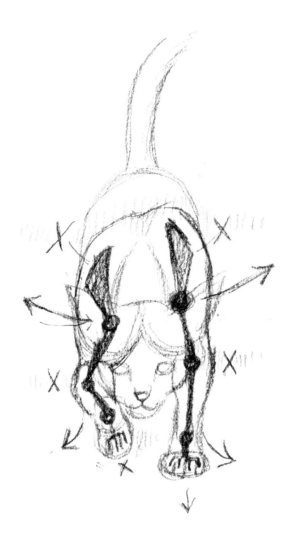

In this view of the same pose from the front, I've emphasized the front legs. Note how the leg that supports the cat (on the viewer's right) is almost straight and the shoulder on that side juts up. The leg that steps forward is bent and the shoulder blade on that side moves down just a little as it hangs down from the body. I used arrows to indicate where in the cat's shoulder and leg joint jut toward the viewer. The X shapes and some shading indicate where the joints recede, angling or pointing away from the viewer.

When cats crouch down and stalk something, their shoulders may become even more pronounced than usual.

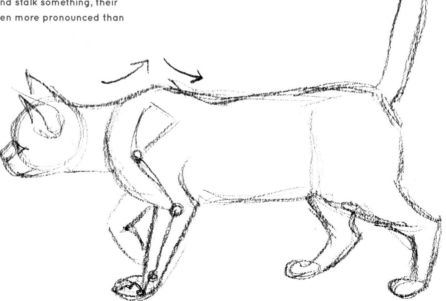

MORE TIPS FOR CONVEYING MOTION: THINK LIKE AN ANIMATOR

Animators think in terms of motion: how to convey subjects' state of mind and intentions by how they move and carry themselves. They pay attention to leg positions; whether the head is crouched down or held high; and other clues that convey life, action, and expression.

SQUASH AND STRETCH

Cats have a slinky, flexible quality to them. One thing that is helpful to remember when drawing a cat in motion is the key principle in animation called "squash and stretch," which refers to how the body contracts or extends as it moves. A cat may appear rounded, its limbs scrunched together as it readies itself to pounce, then leaps forward, stretching out to its full, thin-looking length.

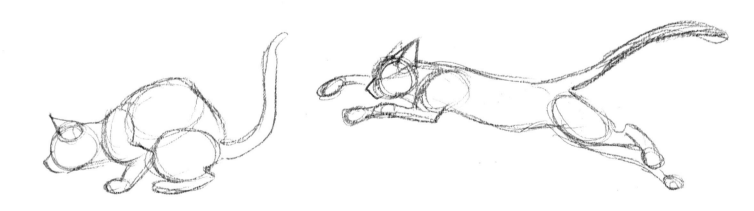

Cat bodies can show the extreme of either squashing or stretching, appearing quite blocky or thin, depending on how they carry themselves at that moment. A sitting cat may appear very rounded and compact but can stretch out thin the next instant.

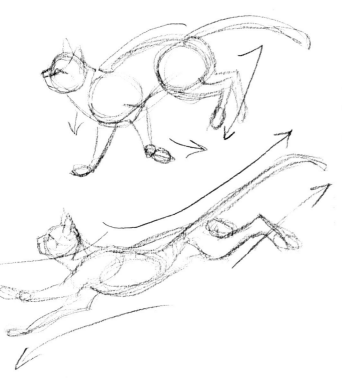

Note how the cat bunches its limbs together (top) as it runs and then stretches out to leap as far as it can (below). This is squash and then stretch.

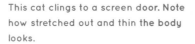

This cat clings to a screen door. Note how stretched out and thin the body looks.

This cat's limbs stretch out as it walks.

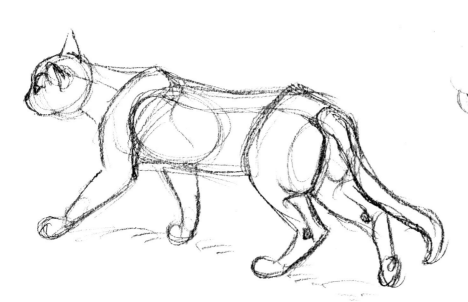

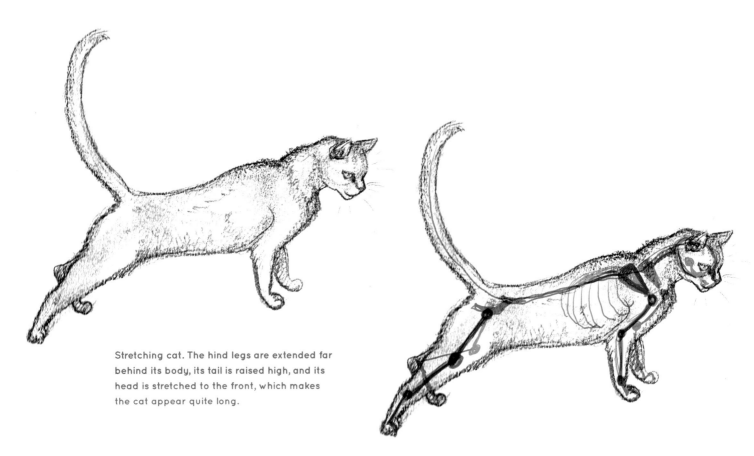

Stretching cat. The hind legs are extended far behind its body, its tail is raised high, and its head is stretched to the front, which makes the cat appear quite long.

A look at the skeletal structure of this cat as she stretches to help you understand how the underlying anatomy affects what you see. Note how the bones of the hind leg stretch out almost (but not quite) straight behind the hip.

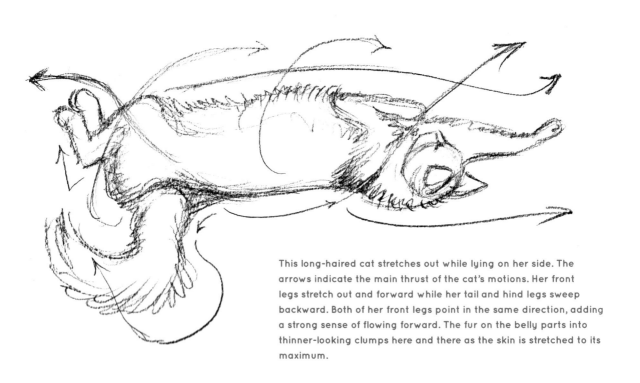

This long-haired cat stretches out while lying on her side. The arrows indicate the main thrust of the cat's motions. Her front legs stretch out and forward while her tail and hind legs sweep backward. Both of her front legs point in the same direction, adding a strong sense of flowing forward. The fur on the belly parts into thinner-looking clumps here and there as the skin is stretched to its maximum.

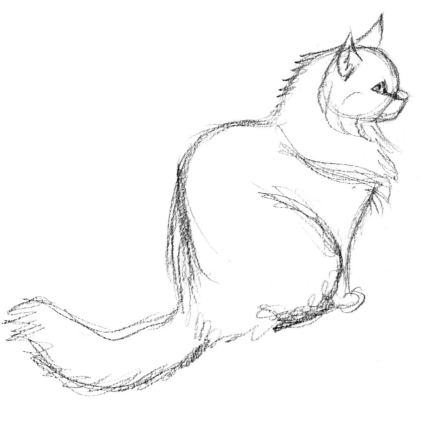

This is the same long-haired cat as the one at the bottom of the facing page. Notice how much more compact she looks as she sits with her legs all tucked in underneath her.

The long hair only adds to the blocky effect by increasing the appearance of volume and mass. Here, I've drawn the underlying skeletal structure and muscles underneath all that thick fur.

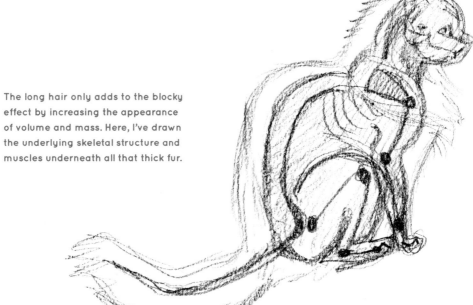

101

WALK CYCLE

Another tool animators use to help them understand how a subject moves is to study the body in motion. How does a person or animal walk, run, jump, trot, and so on? Video or still photos can be studied to see how the legs and body are placed as a subject walks (or makes other cyclical movements). A completed motion is called a cycle, and then the same leg placements start again. Here, I've included a walk cycle and on the facing page a run cycle, showing how a cat's body tends to move as it walks or runs.

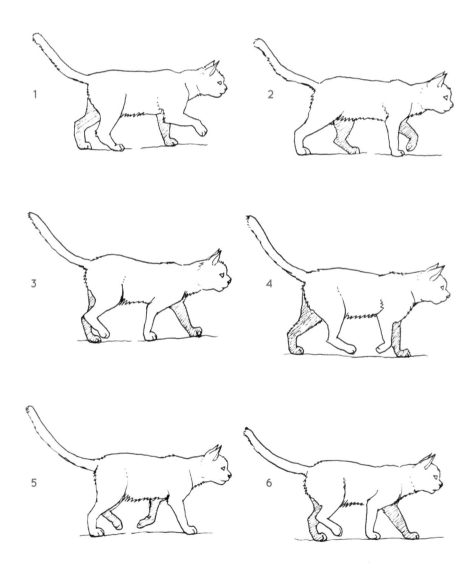

RUN CYCLE

The run cycle can vary depending on how fast the animal is going. A cat using a different gait, such as galloping as fast as it can or simply trotting along, may show leg placement that is different from that of the running cat here.

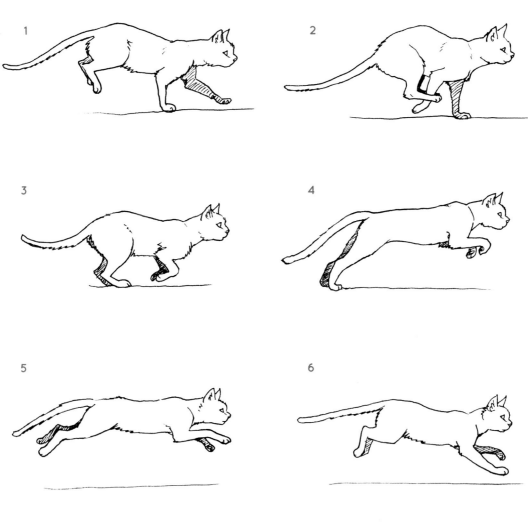

1

2

3

4

5

6

Here's a look at some of the motion a cat's legs can make. Arrows indicate some of the ways different joints can move. Study cats in motion, either from real life or videos and photos, and take note of how the legs can rotate as they stretch out or squash in.

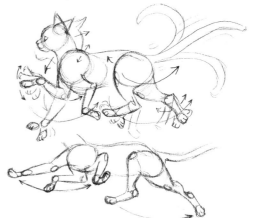

103

DRAWING A SITTING CAT

A sitting cat has an almost snowman-like shape, with a smaller circle for the head and a wider circle on bottom for the hindquarters. The chest forms a medium-sized circle in the middle. You can see this construction in both front and back views of the sitting cat.

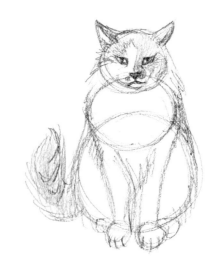
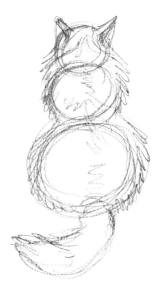

1 Draw three circles. The top one is smallest, for the head. The second is a little larger and overlaps the head circle just a little underneath. The third is more egg shaped, starts at the same place on top as the second circle, and extends down almost twice the length of the second one. It's wider on bottom than on top.

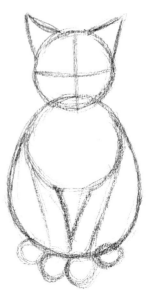

2 Add a horizontal and a vertical guideline inside the head, dividing it into four equal parts. I curve the horizontal line slightly downward, since the cat's face is pointing very slightly downward from this angle. Then add the ears. Draw the front legs, first drawing a narrow triangle that indicates the insides of the legs from the bottom of the chest circle. Draw the outsides of the front legs by taking lines down from the chest circle's sides and sweeping them down to the bottom of the body. Just below the bottom of the body, add the front paws and then hind paws to the sides of those.

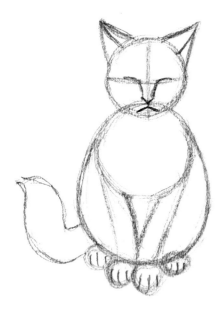

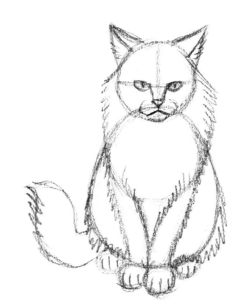

3 Now add lines to indicate the top of the eyes along the horizontal guideline of the head, and connect them with the nose. Draw an upside-down V for the mouth below that, which just reaches the bottom of the head circle. Draw lines to indicate the inside and outside of the ears, for ears that angle back. Add toes to the paws, then add a tail.

4 At this point, add the bottom of the eyes and the rest of the muzzle. Draw the top of the nose pad, and add pupils. Then start to indicate the fur, sweeping down from the ears to form the thick ruff along the cheeks and extending down the neck and chest. Those lines of fur meet up on each side of the chest circle and extend down the front legs. Afterward, draw more shaggy fur along the haunches and tail, and add dewclaws.

5 Finish the drawing by inking it in and erasing the pencil lines. Add a few whiskers and highlights to the eyes as well.

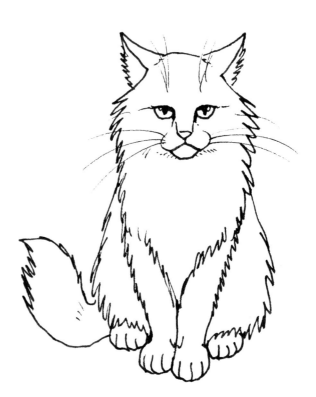

DRAWING A RECLINING CAT

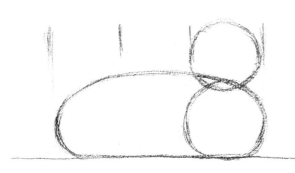 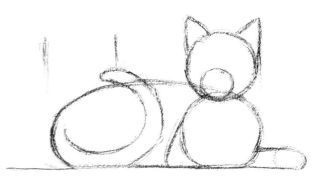

1 Draw a circle for the head, and add another circle of about the same size underneath and just barely overlapping it for the chest. Then draw an ellipse that encompasses the chest circle, and extend it another two head lengths to your left. (I've included some vertical guidelines above the drawing to help with the measurements.)

2 Draw ears on the head, and add a smaller circle on the bottom half of the head to indicate the muzzle. Add a tail curled around the body that sweeps up to rise above the back. It should leave about one head length inside its loop. Add the elbow of the near front leg (a sort of triangular shape just to the left of the chest circle), and draw the far front leg extending to the right of the chest.

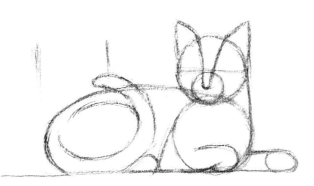 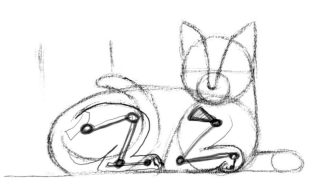

3 Add the near front leg inside the chest circle. The paw is tucked underneath the leg, so the toes won't show. Add the near hind leg, which is somewhat obscured by the tail but can be seen along and under the line of the back. The hind foot protrudes in front of the tail and behind the elbow. Add the nose, extending lines down from the inner corners of the ears to a point right in the center of the muzzle circle, creating a triangular point and heading back up again to the other inner ear corner. If it helps, draw a horizontal guideline across the center of the head to help you place the eyes later. It should line up with the top of the muzzle circle. Finally, add the neck, connecting the head and chest.

Here, I show the basic skeletal structure of the near legs, both front and back, to help you visualize what you're drawing.

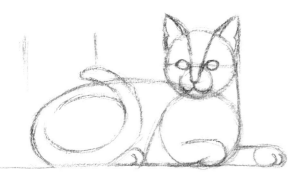

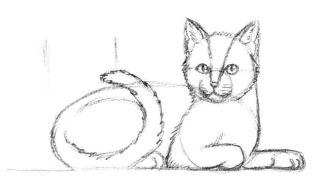

4 Now draw the eyes. These can be indicated by lines coming up from the nose and spreading out along tear ducts until they reach the inner corners of the oval eyes. The eyes align with the horizontal guideline drawn earlier. Under the nose, add the mouth in two curved lines that scoop out and meet the outside of the muzzle circle. Draw the rims of the ears, including a pinched-in area on the outer sides to indicate the ear pockets. Draw toes on the two paws that are visible.

5 Finish adding details, like pupils in the eyes, nose pad, and eye highlights. Draw tufts of hair inside the ears. Draw some of the fur (like the cheek ruffs or on the tail). You can make this a short-haired cat, like this one, or try a longer-haired feline. Draw whisker follicle rows to help guide you when placing whiskers later (and you can add the whiskers now if that helps). I added a dewclaw inside the front leg where the circle of the paw meets the rest of the leg. I also added a few lines above the near front leg, right in the center of the chest circle, to show where the shoulder is.

6 Complete the drawing, placing final lines and erasing unneeded guidelines. Add the whiskers if you haven't already. Add markings if you wish. I added some calico markings to this one.

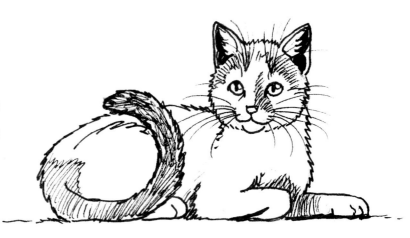

DRAWING A LONG-HAIRED WALKING CAT

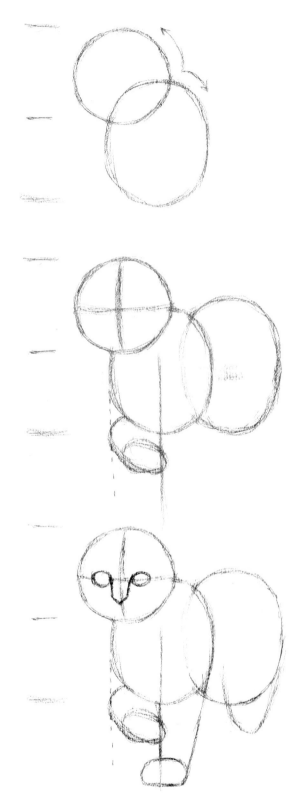

1 First draw a circle for the head and then an oval (longer from top to bottom) overlapping it; the oval (for the chest) should be placed just a little below the head circle and to the right. I've included some arrows showing the space you should leave to the top right. It can also help to measure the head circle, and then before you draw the oval, add another head circle length below it. (These are the three horizontal bars to the left of the drawing, each measurement being one head circle length.) The bottom of the chest oval should line up horizontally with the bottom head circle measurement bar on the left.

2 Now erase most of the overlap line inside the head circle so that it's easier to work more on the features of the head itself. Draw horizontal and vertical guidelines in the head, dividing the circle into four equal sections; curve the vertical line very slightly toward the left side, because the cat will be facing forward but slightly to the left on the drawing as it moves in that direction. Then draw a vertical line that divides the chest in half. Using this measurement as a guide, add a front leg (the cat's right front leg, which appears on the left-hand side here in the drawing). It is raised as the cat lifts its paw and prepares to step forward. To make the leg, draw a curved line from the bottom left part of the chest oval and loop it down into the paw that is tucked under the chest. Note that the paw doesn't extend much beyond the vertical dividing line. It also doesn't extend much beyond the chest on the left side of the drawing (note the dotted line extending from the left side of the chest down to the tucked-in leg). Finally, add another only slightly larger oval behind the chest oval and overlapping it a little. This will be the hindquarters.

3 Draw the eyes, and connect them with the nose. The eyes line up with the horizontal guideline in the head, and the tip of the nose will line up with the vertical guideline. Add the other front leg, using the vertical dividing line you drew for the chest as a guide for the inside of that leg. Draw a paw a little less than one paw length below the tucked-in paw. Keep the paw oval but flattened a bit underneath. Sweep the outer line of the straight front leg up to meet the chest oval. Start adding the near hind leg by making a U shape that extends from the hindquarters. The leg should curl up and start to divide the hindquarter oval about halfway, leaving the rest of the oval for the other leg. This hind leg should almost meet the side of the chest oval but not quite.

A look at the skeletal structure of the cat's front legs gives you an idea of how they are positioned.

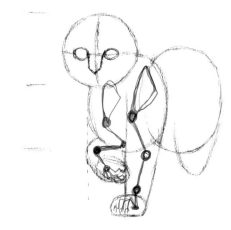

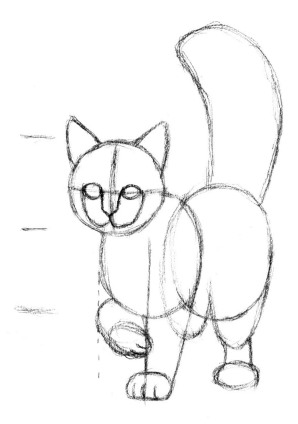

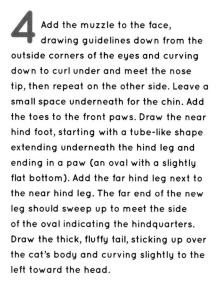

4 Add the muzzle to the face, drawing guidelines down from the outside corners of the eyes and curving down to curl under and meet the nose tip, then repeat on the other side. Leave a small space underneath for the chin. Add the toes to the front paws. Draw the near hind foot, starting with a tube-like shape extending underneath the hind leg and ending in a paw (an oval with a slightly flat bottom). Add the far hind leg next to the near hind leg. The far end of the new leg should sweep up to meet the side of the oval indicating the hindquarters. Draw the thick, fluffy tail, sticking up over the cat's body and curving slightly to the left toward the head.

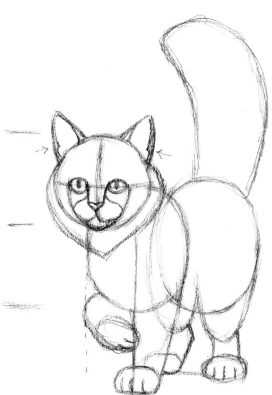

5 From this point, add the full nose pad and the pupils in the eyes. Draw the rims of the ears, adding a slightly pinched-in look inside the ear rim where I've placed the arrows. These lines indicate the ear pockets. Define the chin, and draw the upper part of the muzzle, extending a line from the inner corners of the eyes down and out toward the mouth. Add a ruff of fur around the head, starting under the ears, sweeping down in an almost heart shape to a point at the neck, and then sweeping back up to the other ear. Add the far hind foot and the toes of the near hind foot.

Here I've indicated the basic skeletal structure of the hind legs to help you visualize how they are posed.

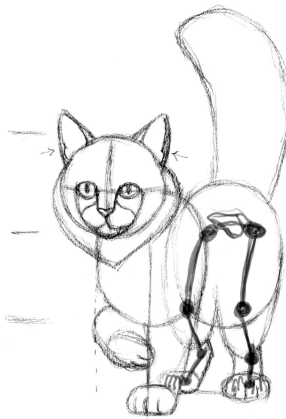

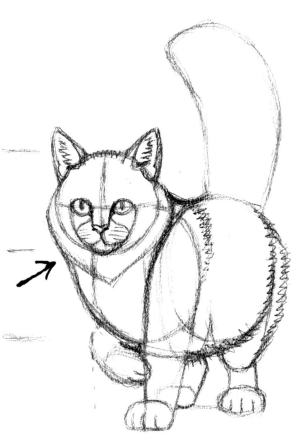

6 Finish drawing the body by connecting and filling in any missing parts. Draw a line from behind the head that sweeps down and connects to the back, giving the cat a neck and thickening the body's appearance. You can draw a furry ruff behind the shoulders, too. Draw a line for the chest and belly that connects the outline of the cheek fur (see arrow) down to the chest and under the cat, ultimately connecting with the right side of the hindquarters. This is a furry cat, so it has thick fur around its belly and legs. Add thicker fur ruffs on the hind leg, and draw dense hair on the neck by sweeping a line up from the near front leg to the shoulder. Finish by adding details such as the whisker rows on the muzzle and a tuft of hair inside the ears. I also added some depth to the ears by bringing them down inside the outline of the head slightly at their base.

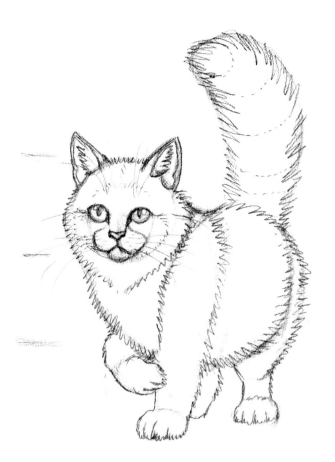

7 At this point, you can erase or lighten most of the guidelines and draw the cat's final details, such as the thick fur. The paws have long hair like the rest of the cat, so the toes appear slightly uneven and shaggy as fur covers details. I drew in the whiskers, including the set over the eyes, and placed highlights next to the pupils. The tail is basically a furry tube. (I've drawn dotted lines that wrap around the tube shape of the tail to give you an idea of the fur's direction.) It becomes compressed toward the tip because it is curled to the side, and the denser fur overlapping itself creates more shadow in the hair.

8 Finish the drawing by placing the final, darker lines. I used pen and ink and then erased the pencil lines underneath. Use short, back-and-forth pen strokes to draw the fur's outline, occasionally leaving empty spaces in between pen strokes. Note how the tail tip is curled, and because of the more compressed and shadowy fur underneath it, it appears a little darker.

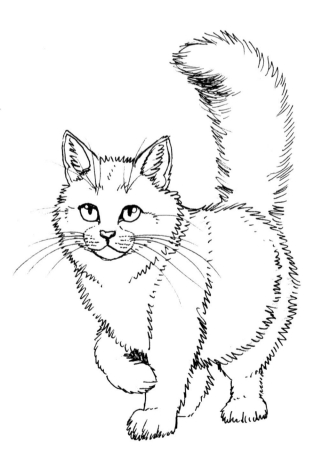

Chapter Five

PATTERNS
& BREEDS

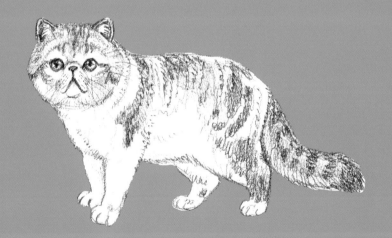

Covering all cat markings and breeds is beyond the scope of this book, but this chapter will cover some of the more well-known or notable breeds as well as some color variations found on many cats.

PATTERNS AND COLORS

There are some notable colors and patterns worth mentioning that may show up in cats. These are not breeds, which we'll get to later in this chapter, but are distinctive colorations that occur in cats. Some are linked to breeds (like colorpoint Siamese, for instance), and others (like calico cats) may be found in various breeds or mixed-breed cats.

CALICO

Calico cats are usually female. Calico coloration refers to a spotted or parti-color coat that is white with patches of two other colors (often orange and black). Dilute calicos (or light calicos) have blue-gray, cream, and white patches instead of the traditional black, orange, and white.

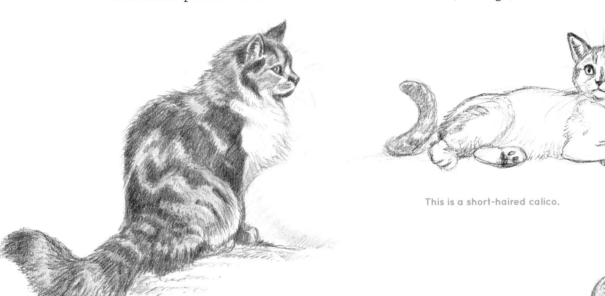

This is a short-haired calico.

Calicos can occur in various breeds as well as mixed breeds of cats. This is a long-haired calico.

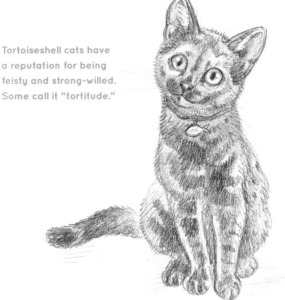

Tortoiseshell cats have a reputation for being feisty and strong-willed. Some call it "tortitude."

TORTOISESHELL

Tortoiseshells are similar to calico cats and are usually female. They have patches or mottled patterns of two colors (often black and orange or something similar) but little to no white.

BLACK

Black cats have a sleek sheen to them. When drawing a black cat, you can use that sheen to help you define the cat's anatomy.

To draw the fur of a black cat, I drew the outline and put in most details. Then I shaded the cat's body, making sure my pencil strokes all pointed in the direction of the feline's fur.

The black fur has a sheen to it and using that sheen will help you define different parts of the cat's body. In this drawing, I wanted glossy highlights of lighter fur along the outside rims of the shoulders and on the forehead and nose. To create this effect, first I darkened all areas of the fur that weren't going to be part of the glossy highlights. I applied pencil strokes and then went over the drawing and darkened lines again, including along the eyes and inside the ears. I also added details to the cat's bow tie.

The last step is a more subtle one. I added light pencil strokes in the highlight areas to soften the contrast between dark and light areas. I left a few places of white paper showing underneath to really emphasize those spots (such as the ridge of the nose and tops of the shoulders).

TABBY

The tabby coloration is a well-known and common feline color pattern. In fact, there are four major types of tabbies: classic, mackerel, spotted, and ticked.

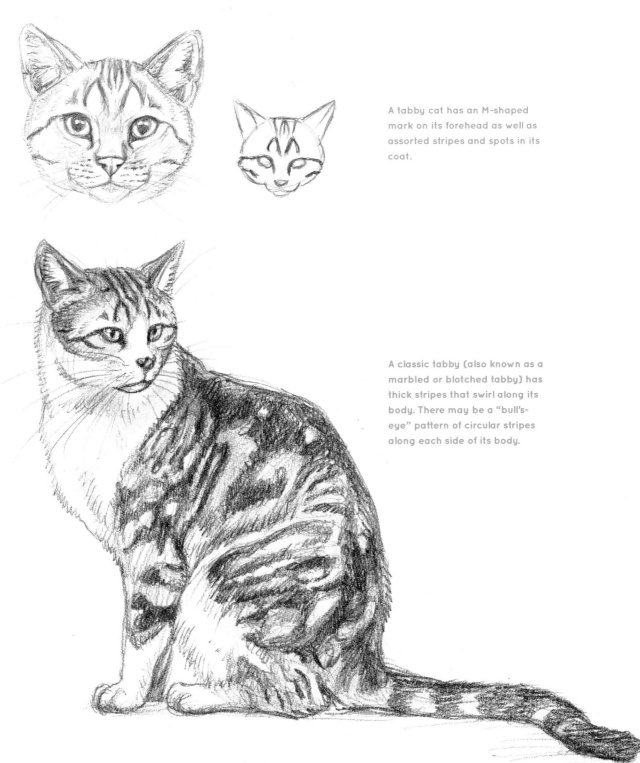

A tabby cat has an M-shaped mark on its forehead as well as assorted stripes and spots in its coat.

A classic tabby (also known as a marbled or blotched tabby) has thick stripes that swirl along its body. There may be a "bull's-eye" pattern of circular stripes along each side of its body.

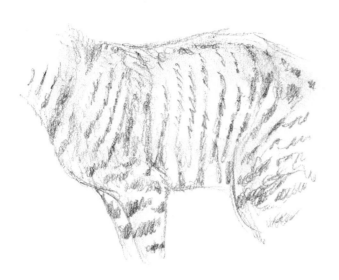

A mackerel tabby has vertical, thin, dark stripes on its body.

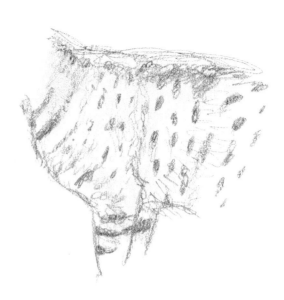

A spotted tabby has, predominantly, spots (rather than stripes) as markings, though it may still have some stripes.

A ticked tabby has a salt-and-pepper appearance due to the different bands of colors on each of its hairs. This is also known as an agouti coloration. The Abyssinian is one breed of cat that has this coloration.

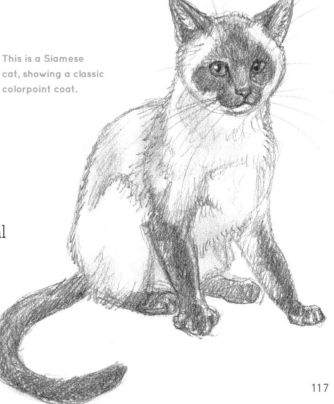

This is a Siamese cat, showing a classic colorpoint coat.

COLORPOINT

Colorpoint markings, such as those found in Siamese cats, refer to coats with one basic, light color accented by darker "points" on the ears, nose, legs, and tail. These color points may be seal point (dark brown), chocolate point (lighter brown), blue point, lilac point (a pale, pink-gray coloration), or other colors.

BREEDS

In this section is an overview of some of the more distinctive or notable cat breeds.

ABYSSINIAN

The Abyssinian is both a very old breed and a popular one. It is believed to have originated in what was once Abyssinia, now called Ethiopia, and may have roots going all the way back to the sacred cats of the ancient Egyptians. This is a sleek, slender cat with long legs. Its coat is distinctive and is ticked, or agouti, with several bands of color on each hair. Overall, the coat is usually a coppery red to fawn color. Common colors include the warm red-brown with black tick, known as ruddy or usual, and a lighter copper color, known as sorrel or cinnamon. There are also blue, fawn, lilac, and other less common colors. The Abyssinian can be willful and demanding, but it is also sweet natured and playful. It is intelligent, curious, and generally quiet, and it loves to get attention from its family.

The Abyssinian has a somewhat wedge-shaped head with large ears and large almond-shaped eyes. It has an M-shaped marking, like the tabby, above its eyes.

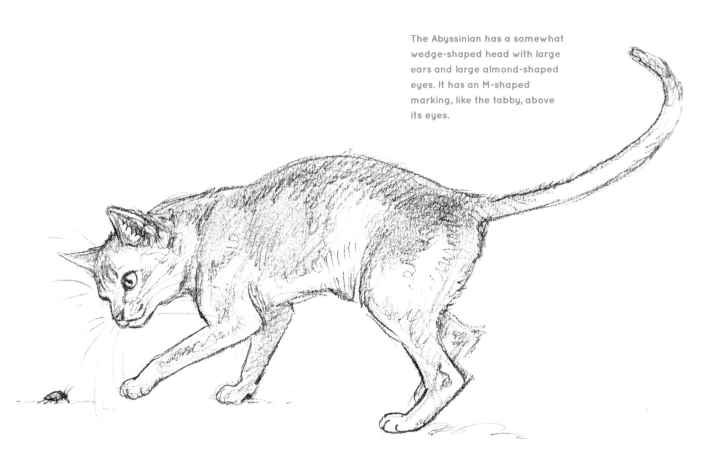

DRAWING AN ABYSSINIAN HEAD

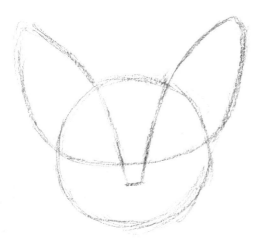

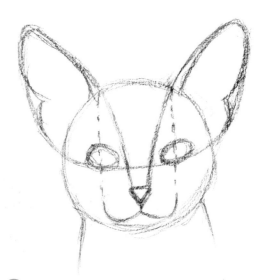

1 To begin drawing an Abyssinian cat's head, draw a circle, and then draw the ears. Connect under the ears with a horizontal line that sweeps across, slightly curved, around the center. Draw the nose, extending the inner corners of the ears down across the horizontal center line, leveling off where the top of the nose pad will be and arcing back up to the opposite inside ear corner.

2 Draw the eyes resting on top of the horizontal dividing line. Draw ear rims and a pinched-in area for the ear pockets. Draw the rest of the nose pad, and add the mouth. The outside of the muzzle lines up with the inside corners of the cat's ears (see dotted line); the eyes should be centered at about that point, too. Add a neck.

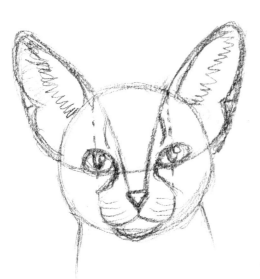

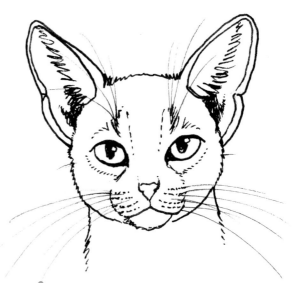

3 Connect the inside corners of the eyes with the muzzle (arcing down and then away to meet the outside lines of the muzzle). Draw the whisker follicle rows on the upper muzzle (and the whiskers, too, if you wish). Whisker rows tend to be darker in color than the surrounding fur. Add the pupils and highlights in the eyes, nostrils in the nose, and a tuft of hair inside the ears. Add curved markings above the eyes and just slightly outward from the tear duct.

4 Finish the drawing, adding final lines and erasing unneeded ones. The marks above the eyes almost look like dark V shapes with light streaks to the left and right.

AMERICAN SHORTHAIR

The American Shorthair and British Shorthair (opposite) are both short-haired cats that share ancestry but are two distinct breeds. The American tends to be larger and leaner than the rounder, smaller British Shorthair. The American Shorthair was brought to America from Europe by early settlers, including those who arrived on the famous *Mayflower*. These were working cats, possessing powerful, muscular bodies that helped them in their job of ridding settlers' homes of rats and mice. The American Shorthair is slightly longer than it is tall. This breed has a comparatively large head; a round face with large, round eyes; and rounded ear tips. It comes in a variety of colors and patterns, including many tabby patterns (this is a classic tabby, which has bold, swirling patterns on its sides). The American Shorthair is friendly and calm, social but still independent.

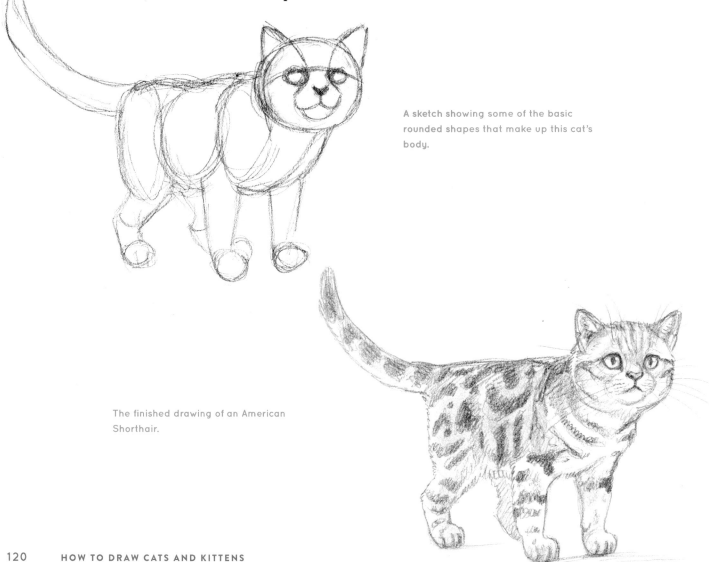

A sketch showing some of the basic rounded shapes that make up this cat's body.

The finished drawing of an American Shorthair.

BRITISH SHORTHAIR

The British Shorthair is an old breed, dating back thousands of years. It has a dense, short coat; short but muscular legs; a broad chest; and a thick tail. Males are larger than females and may be rather jowly in the jawline sometimes. The head is comparatively large and round, with chubby cheeks and large, wide-set eyes. Those eyes come in many different colors. The coat comes in a variety of colors and patterns as well, though the classic blue color (with orange eyes) is especially well known. Like the American Shorthair, this is a calm, gentle cat around people.

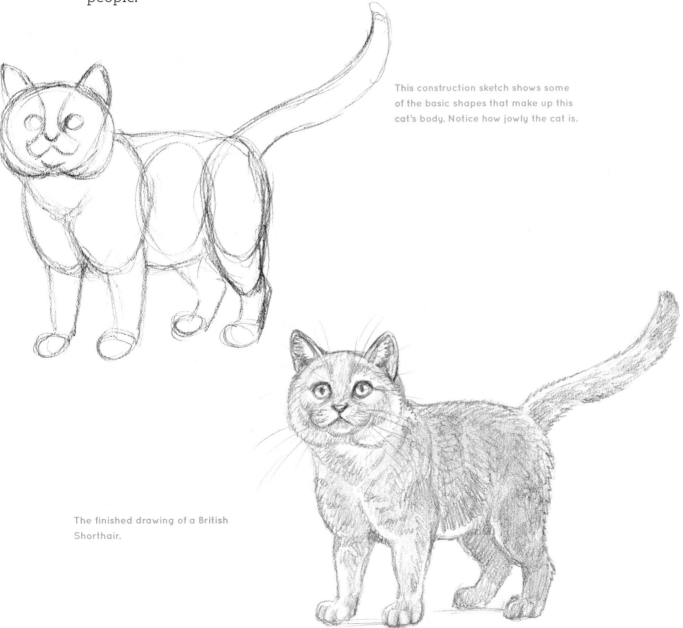

This construction sketch shows some of the basic shapes that make up this cat's body. Notice how jowly the cat is.

The finished drawing of a British Shorthair.

EXOTIC SHORTHAIR

The Exotic Shorthair is basically intended to be a short-haired version of the Persian (opposite) for people who can't or don't want to deal with the Persian's longer hair. It is very stocky, or cobby, like a Persian, and has a broad chest and muscular shoulders. The legs are comparatively short and the paws large and rounded. There are tufts of hair between the toes. The Exotic is a calm, gentle cat that enjoys showing affection. Its fur is plush and comes in numerous colors and patterns, like the Persian.

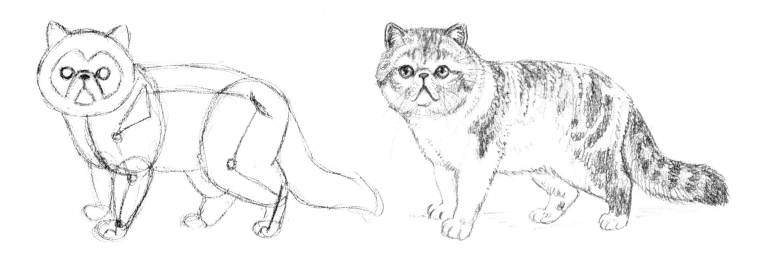

Preliminary sketch. I've drawn some of the basic geometric shapes as well as showing a simplified bone structure.

Finished drawing.

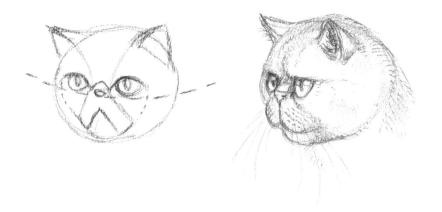

The Exotic Shorthair has a comparatively large and round head, short nose, and short neck. Its eyes are round and set far apart. Its eyes are often gold or copper but can be green or blue. Its ears are small and rounded.

PERSIAN

The Persian originated in the ancient country of Persia, now Iran. It is known for its flat face and snub nose on a rounded head. This popular and distinctive cat breed comes in several variations: some, known as "peke-faced" Persians, have extremely flat faces; the nose, chin, and forehead are almost in alignment vertically from a profile view. Then there are older-type, "doll-face" Persians, which still have a short muzzle, but it isn't as flat as in the peke-faced cats. The Persian's body is short-legged, heavy-boned, and stocky with a long, bushy tail. It is a very quiet and mild-mannered feline. Its fur is long, flowing, and soft. The Persian's color patterns encompass most cat colors and patterns, ranging from solid to multicolored. Its eyes may be various colors as well.

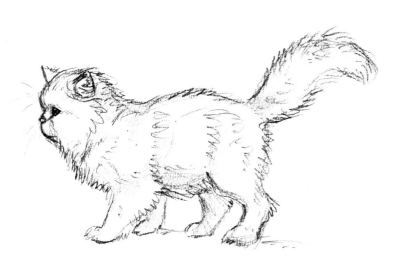

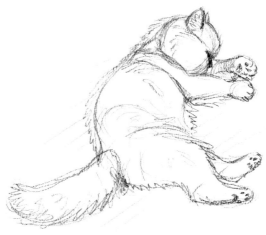

The Persian has a very rounded head and face and comparatively small ears.

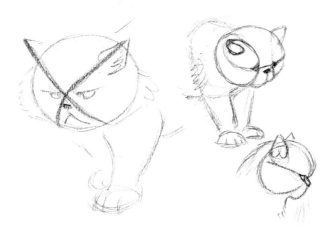

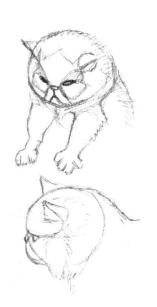

DRAWING THE PERSIAN

1 Begin by drawing what is basically an upside-down kite or a large, thin triangle with a smaller triangle pointing out from its bottom. (The smaller triangle will help you draw the cat's legs later.) Add an oval for the head that overlaps the larger triangle and extends a little out from each side. It should be wider than it is tall. The tip of the triangle should extend above the head oval a little bit. The height of the head oval from bottom to top should equal the distance below it to the kite's bottom (see the horizontal lines on the right depicting head lengths). I also added a vertical guideline right up the center of the triangle.

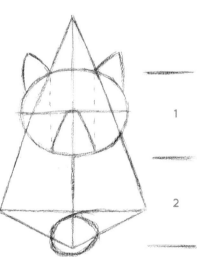

2 Draw a central horizontal dividing line across the head oval. Now draw the ears on top of the head oval, starting the inside corners of the ears where the triangle juts through the oval. Measure down from that spot where the inside corners of the ears meet the head (see dotted lines) all the way down to the bottom of the head. Use the space between to help you draw the muzzle, which is almost triangular. The line of the muzzle extends up, then goes slightly horizontal along the center dividing line, then back down again. At the bottom triangle of the "kite," draw an oval at the center, jutting out from the bottom slightly. This will be the paw extending from the cat's left leg (on your right). The other leg will have a tucked-in paw.

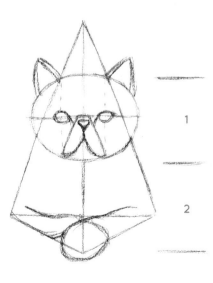

3 Start adding details. Center the round eyes at the intersection of the horizontal dividing line and the dotted lines placed earlier. Draw the tear ducts, connecting the eyes to the muzzle. Draw the muzzle, which in the Persian's case is quite long (vertically) and narrow compared to that of other cats. Draw the stubby nose, which lines up with the bottom of the cat's eyes. Add rims to the ears. Start defining the short legs of the Persian, curling the line of the chest up a little from the widest section of the "kite" and adding width to the legs.

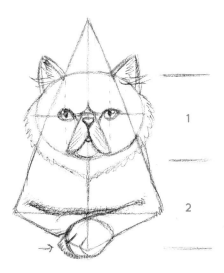

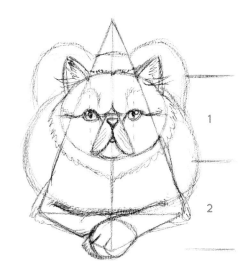

4 Place more details, including the pupils and highlights in the eyes and whisker rows on the muzzle (which slant downward, just like the muzzle). Add the mouth and chin, and draw brows above the cat's nose, giving it almost a W shape above the muzzle and eyes. Draw tufts of hair inside the ears, including some extra-long tufts that extend past the ear itself and outward. Draw a ruff of fur around the cheeks and bottom of the head. Further define the legs, adding some hair, and then add thick fur to the toes on the paw, letting it extend out and toward your left side (see arrow).

5 Add more fur on the top of the head and the legs. Draw the rest of the body, adding the shape of an oval starting from the top of the head oval and around to meet the bottom of the chest and back again. That will be the sides. Add the legs bunched up in the back around the top of the head oval. Note how I used the triangle shape to measure where the back would be and placed the legs on either side. I also added a bit of fur to the brows above the eyes and the creases on the outside corners of the eyes.

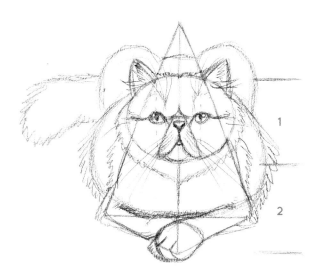

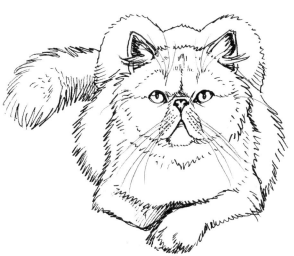

6 Add the tail (the top of the tail here lines up with the top of the head). Draw shaggy fur extending out from the sides of the body, the thick ruff of the neck, and the shoulders. Draw the whiskers, and keep in mind that a Persian's whiskers may droop down along with its muzzle, pointing at more of a downward angle than usual.

7 Draw the final picture over your base drawing. Here, I used pen and ink over the pencil I'd used to draw the cat originally. Finish by erasing your pencil work, leaving only the final lines.

BENGAL

The Bengal breed actually has some Asian Leopard cat (a species of wild cat) crossed with domestic cats. It has a striking coat that is spotted, marbled, and striped, sometimes featuring rosettes like those on a wild cat, and has a light belly. The soft, thick coat is creamy orange to light brown in color (or sometimes a silver-gray) and is short to medium in length. Occasionally, other colors are seen as well. The tail should have at least seven bands along its length. The Bengal has a gentle, domestic-cat temperament and can be quite playful. It may enjoy water, unlike many cats.

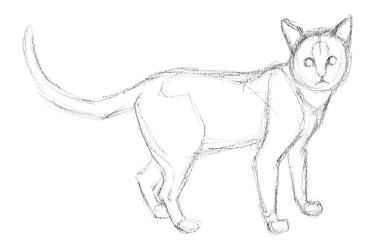

A quick sketch to get proportions right.

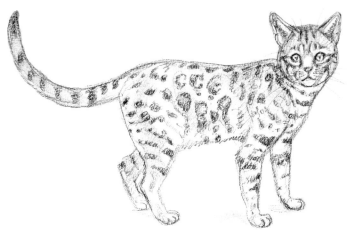

The finished drawing.

The Bengal may have gold, green, or blue eyes. Its face has light horizontal striping called "mascara" along the eyes.

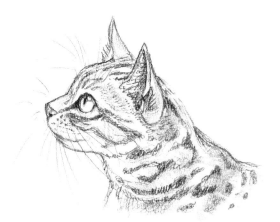

BIRMAN

The Birman can look a little like a long-haired, silky Siamese, with pale body complete with dark points on the face, ears, legs, and tail; however, its white paws are distinctively Birman. Its body is rectangular and stocky. This cat has rounded, deep-blue eyes set in a wide face. Its ears are set wide apart. The Birman breed has roots in Burma and France. This is a sweet, friendly cat that enjoys the company of people.

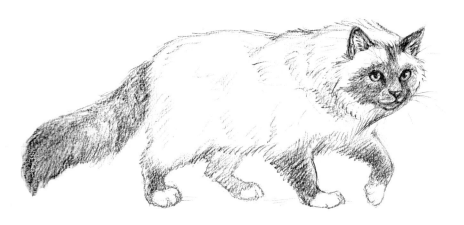

Note how in this pose and from this angle, this Birman's body takes on an almost rectangular shape.

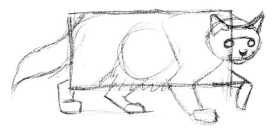

The Birman has a rounded face and a Roman nose: there is a definite stop (see arrow), or break, between the forehead and the muzzle. Ear tips are slightly rounded, and ears are wide at the base.

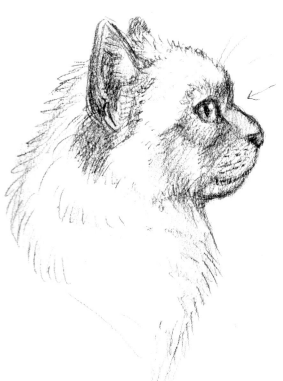

CORNISH REX AND DEVON REX

These two cats are very similar in appearance but are distinct breeds. Both are characterized by a recessive gene that causes a fine, curly, and mostly non-shedding coat. The recessive gene is different for each breed, and thus they can't crossbreed and produce curly-coated offspring. The Cornish Rex has no guard hairs, while the Devon has shortened guard hairs in addition to the downy under-coat. The Cornish Rex originated with a curly-haired kitten born in Cornwall, England, in 1950, and the Devon Rex originated with a similar curly-coated kitten born in Devon about ten years later.

The Cornish Rex is a sleek, swift, and affectionate cat that is quite active and may enjoy fetching like a dog. It comes in a variety of coat colors and patterns as well as various eye colors. Its body is elegant, curved, deep-chested, and long-legged with a thin, whip-like tail.

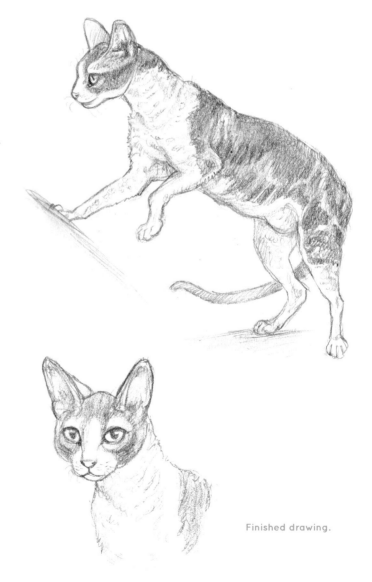

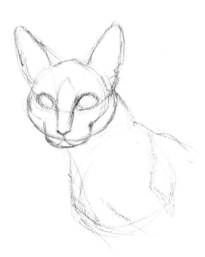

Its egg-shaped head features comparatively large, rounded ears and eyes, and high cheekbones. Like the Devon Rex, the Cornish Rex has curled, sometimes short or absent whiskers.

Finished drawing.

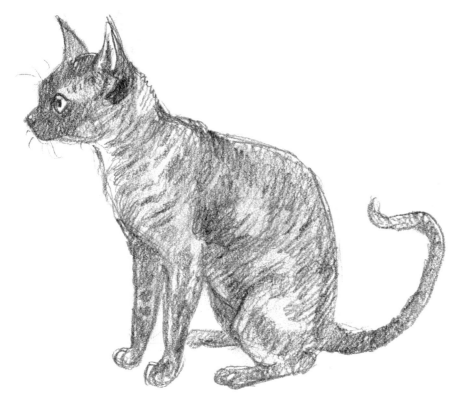

The Devon Rex is sometimes called an "alien cat" or "pixie cat" because of its unusual appearance. Like the Cornish Rex, the Devon Rex is very intelligent, active, and affectionate. The Devon likes to stay close to people and sometimes enjoys perching on its human companion's neck or shoulder. It has a curvy body, long legs, and skinny neck.

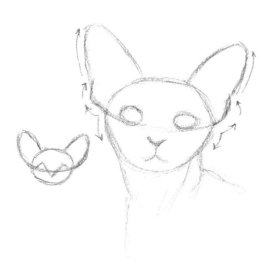

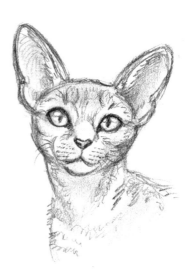

The Devon Rex has large and low-set ears, large eyes, and a slightly upturned nose. This preliminary sketch shows some of the basic shapes of the head. The arrows point out some of the more distinctive curves and pinched-in areas on this cat's head.

Finished drawing.

MAINE COON CAT

This striking breed is one of the largest domesticated cats, weighing as much as thirty pounds. It reaches its full size at about three to five years old. It is known for its ties to the state of Maine, where it is the official state cat. This rugged feline has a muscular body with long, shaggy fur that is snow- and water-resistant. Its tail is thick and furry. The Maine Coon comes in many different colors and can have green, gold, or copper eyes. White cats may have blue eyes. The Maine Coon is playful, friendly, and enjoys people's company, though it may not be a lap cat. It is usually a good mouser.

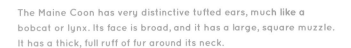

The Maine Coon has very distinctive tufted ears, much like a bobcat or lynx. Its face is broad, and it has a large, square muzzle. It has a thick, full ruff of fur around its neck.

DRAWING A MAINE COON HEAD

1 Draw a square, and divide it into four equal horizontal sections. Add a vertical center line, dividing the space into eight equal rectangles.

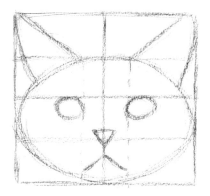

2 Draw an oval for the head, with the top lining up with the top horizontal line (not the top of the box) and the bottom hitting the bottom of the box. Draw ears that extend to the top upper corners of the box. Draw eyes that are placed just below the middle horizontal line. Then add a mouth and nose (the lower portion of the nose should line up more or less with the bottom horizontal line). If you wish, draw a line (dotted in this case) extending down from the inside corners of the ears to help you line up the inside corners of the eyes and the outside corners of the mouth.

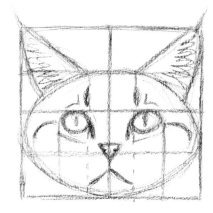

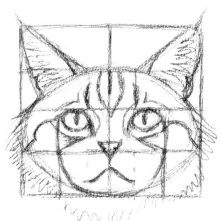

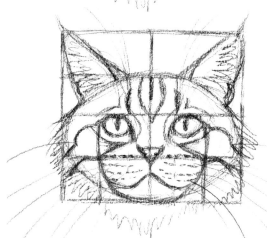

3 Add pupils and highlights to the eyes and nostrils to the nose. Draw long tufts of fur inside the ears and the distinctive tufts on the tips of the ears. Add another set of lines to help with measurements by drawing vertical lines coming down the outside corners of the eyes. Begin placing some of the markings. There is a short, thick stripe coming up above the eye that lines up (more or less) with the inside corner of the ears, eyes, and mouth (see dotted lines). To the outside of that is a wide V-like marking where light color meets darker color. Also add the light stripes below the eyes and dark stripes extending from the outside corners of the eyes.

4 Add more to the ear rims, including ear pockets if visible. Add markings along the forehead (like a broad V shape between the ears). Draw the thick cheek ruff of fur around the head, and don't be afraid to draw outside the box. Continue the eye stripes from the outside corners of the eyes all the way to the edge of the ruff. Draw the light stripes along the tear ducts. Use the lines you drew in the last step, extending down from the outside eye corners, to help draw the muzzle by adding a broad rounded shape that curves along the chin and then back up to the opposite outside eye corner. Draw a > or < mark under each eye, depicting the eye stripe and where the top of the muzzle meets the nose and cheek. Note how the bottom corner of each mark meets the bottom intersection of dividing lines on either side of the face.

5 Finish blocking in the drawing, completing the muzzle by extending the corners of the mouth back up to the outside line of the muzzle, giving the cat a broad and somewhat square muzzle. Draw stripes coming from the corners of the muzzle out to the cheek ruff. Add the whisker rows, and add the whiskers if you wish.

6 Finish the drawing, erasing the unneeded guidelines. I've included examples of a few of the kinds of strokes I used with my pen. There were lots of quick strokes to indicate a furry, shaggy outline. I let my pen leave the paper and create some blank spaces. On the left are a bunch of the shaggier lines I used: the top row shows the actual lines; on bottom is the basic jagged outline of hair that the shorter pen strokes are following. Try to indicate tufts of hair almost in a shark-tooth pattern, except not that regular. Real hair is irregular and random at times in the way the wind blows it around. On the right are the sorts of strokes I used to create outlines for areas with shorter hair, such as the muzzle—one tiny stroke above the other, facing in the direction the fur points.

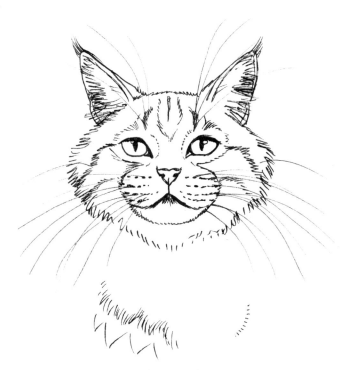

RAGDOLL

The Ragdoll is named for the propensity some cats have to go limp when held by a person. It is a very affectionate cat that is relaxed with people and gets along with other pets. Developed by Ann Baker in America in the 1960s, this breed is one of the largest, weighing twenty pounds or more at times. Its body is broad and heavy-boned, with large, round paws. It comes in multiple color variations. The three main ones are colorpoint, mitted (similar to colorpoint but with white paws, belly, and chin, with or without a white blaze up its nose), and bicolor (white inverted V-shaped blaze up the face, white belly and legs, and sometimes white patches on the back).

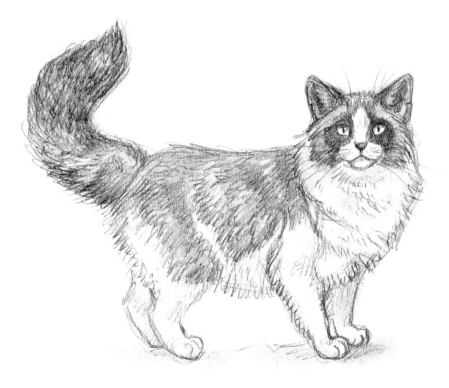

The Ragdoll has blue eyes and a long, plush coat.

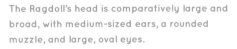

The Ragdoll's head is comparatively large and broad, with medium-sized ears, a rounded muzzle, and large, oval eyes.

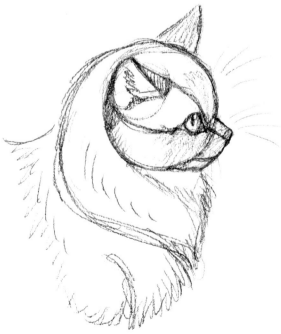

RUSSIAN BLUE

True to its name, the Russian Blue originated in Russia, though it was originally named the Archangel cat. This cat is known for its plush, short double coat of blue-gray fur and its bright green eyes. Its silver-tipped hairs give it a silvery sheen. A few cats may be black or white, but those colors are not accepted by all cat associations. Its body is lean and muscular, giving the breed an elegant look. The Russian Blue is an active, intelligent, and affectionate cat that prefers a stable environment. This is a sensitive, observant cat that can become quite attached to individual people.

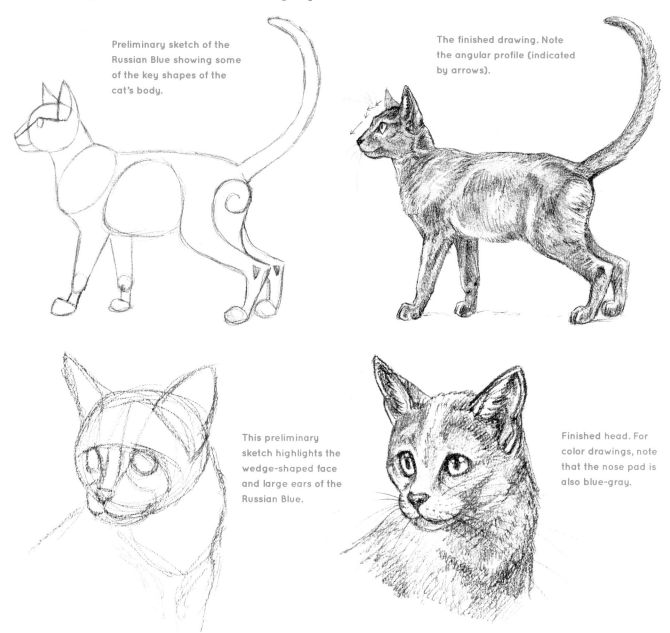

Preliminary sketch of the Russian Blue showing some of the key shapes of the cat's body.

The finished drawing. Note the angular profile (indicated by arrows).

This preliminary sketch highlights the wedge-shaped face and large ears of the Russian Blue.

Finished head. For color drawings, note that the nose pad is also blue-gray.

SCOTTISH FOLD

The Scottish Fold is named for its ears, which fold forward and down on its head, giving it an owl-like appearance. This is a soft-voiced cat that is friendly but tends to become especially attached to its caregivers. It is a hardy breed and may be inclined to adopt unusual poses, such as standing on its hind legs or sitting with hind feet sprawled and front paws resting on its belly.

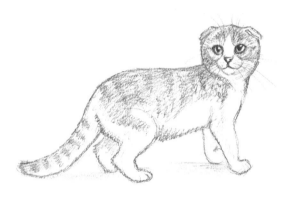

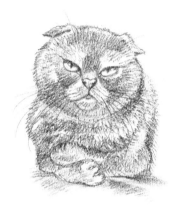

The Scottish Fold has a medium-sized body and is generally rounded in shape. It has medium to short legs. Its coat can be long- or short-haired and comes in a wide variety of colors and patterns.

The Scottish Fold's head is rounded, with large, widely spaced, round eyes. Its head is domed, its nose is short and slightly curved, and it has a short neck.

DRAWING A SCOTTISH FOLD HEAD

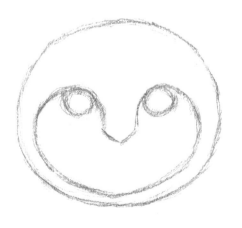

1 Start out with a very rounded, owl-like head; then start placing details such as the eyes and nose.

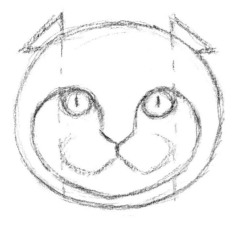

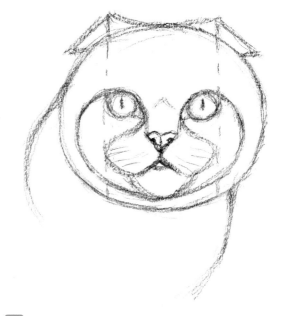

2 Note how the outside corners of the eyes, topmost parts of the ears, and the outside edges of the muzzle all line up vertically (see dotted lines).

3 The cat's head after I added more details, especially around the muzzle, chin, and ears.

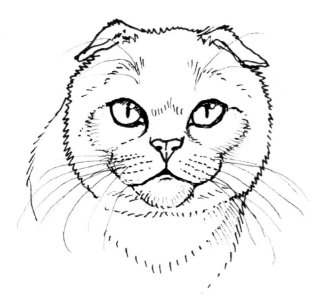

4 The cat's head after I added the final inks and erased the pencil lines.

SIAMESE

The Siamese is one of the best-known cat breeds, an elegant feline with striking colorpoint coloration and vivid blue eyes. The modern Siamese has a slender, elongated body, long legs, and comparatively small feet. It comes from Thailand, formerly known as Siam; however, Siamese cats were originally rounder and heavier than they can be today. Cats that share the original form's rounded, more typically shaped head are known as "applehead" Siamese, as opposed to "modern" Siamese with triangular, wedge-shaped heads and large ears. The applehead Siamese is beginning to be classified as the Thai cat. The modern Siamese, with its more triangular and stretched-out features, can look quite different; however, both types share the colorpoint markings and blue eyes. Siamese used to be known for kinked tails but it is less common now to see this feature. The Siamese cat is vocal, affectionate, and lively.

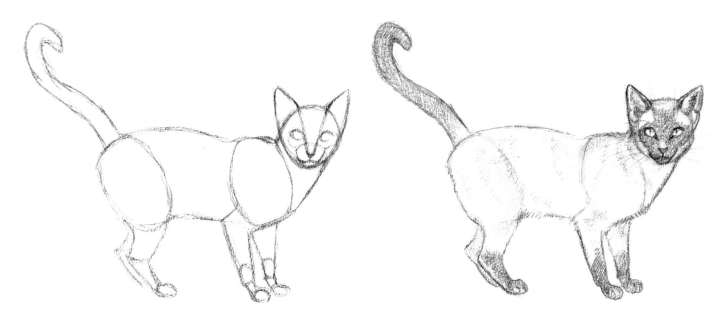

The modern Siamese has a long, thin body, long neck, and a thin tail. Its fur is short and glossy and comes in colorpoint, often seal point (dark brown), but blue point, chocolate point, lilac point, or other variations are also seen.

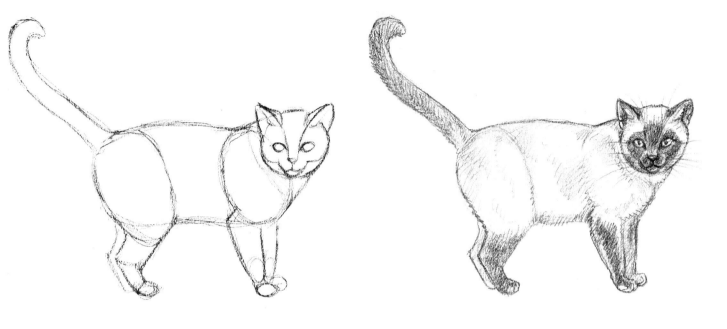

The applehead or Thai cat
has a rounder, more classic
cat physique.

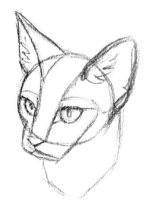 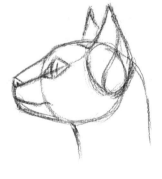

The modern Siamese has a very triangular
head. The ears are large and emphasize
the triangular appearance. Its muzzle is
comparatively long, and the nose is fairly
straight.

DRAWING A RECLINING SIAMESE

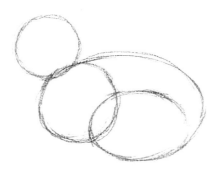

1 Draw a circle for the head, a slightly larger circle for the chest, and a spiral looping around for the body and hind leg.

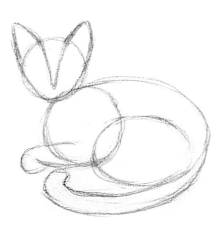

2 Add the ears and draw the nose as a long upside-down triangle extending down from the inside corner of one ear up to the other. The tip of this triangle will be the nose, near the bottom of the head. Draw the front leg using a line sweeping from under the chest circle and extending out. The paw is tucked under the leg, so not all of it is visible. Add the tail.

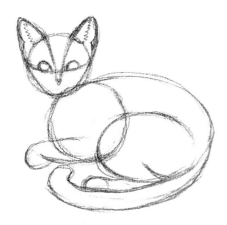

3 Draw a downward-curved horizontal line in the center of the head connected under the outside corners of the ears. Draw ovals for the eyes, placing the bottom of the eyes on that dividing line. Draw the rims and a pinched area for the ear pocket. Add the hind foot and a small line extending up from the heel to show the folded leg.

4 Draw the pupils, nose pad, and mouth. The mouth curves up into the outside of the muzzle, which should line up vertically with the pupils (see line extending up the head to the inside corners of the ears through the eyes). Add toes to the hind foot and some fur on the belly behind the front leg.

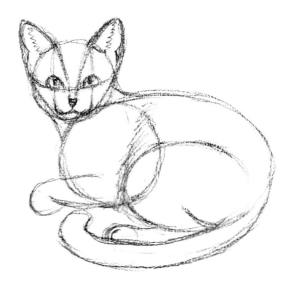

5 Finish drawing the muzzle by connecting tear ducts to the outside top of the muzzle. Block in where the dark mask of the Siamese's face surrounds the eyes and muzzle. It tucks in along the cheeks. Add whisker rows and the rest of the dark markings on the legs and tail.

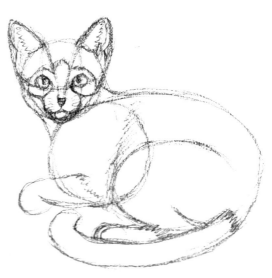

6 Finish the drawing, defining the final outlines and erasing unneeded lines. Shade the mask, legs, ears, and tail.

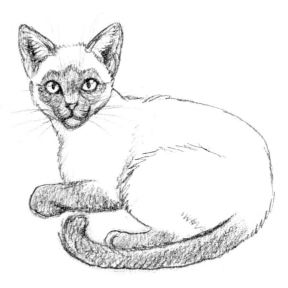

IN CLOSING

The enigmatic cat has called upon people's imaginations for centuries. It is a familiar fixture of our childhoods, cartoons, art, and culture. It is a friend, a confidante, a charmer, a mystery, and a protector, all wrapped up in an elegant package—a fusion of form, function, and finesse that appeals to the human eye and heart. Modern artists have more advanced tools than the artists of ancient times, but the human desire to portray beautiful things connects us all. Now is your time to pick up a pencil or an artist's tablet and see what your contribution will be. Aloof, sleek, and sharp, or fluffy and adorably cute, or fierce, determined predator: cats are all these things and more.

I hope this book helps take some of the mystery away and helps readers understand the feline form and behavior better. I hope it helps you improve and inspires your art. However, some mystery will always remain. For in the end, the cat reveals some secrets slowly and only when it chooses. Approach cats and draw them—with respect and appreciation and ultimately, if you're lucky, you may find that a cat chooses you.

ABOVE: This friendly cat has light tabby markings.

CATS ARE PLAYFUL
CATS ARE NICE
CATS ARE CHASEFUL
CATS CHASE MICE

I present to you, dear readers, a poem that I wrote when I was 7 years old. "Chaseful" is not really a word, but I didn't know that at the time. Sometimes when you are creating art, you let go of the rules and decide to just have fun.

INDEX